SCHIELE

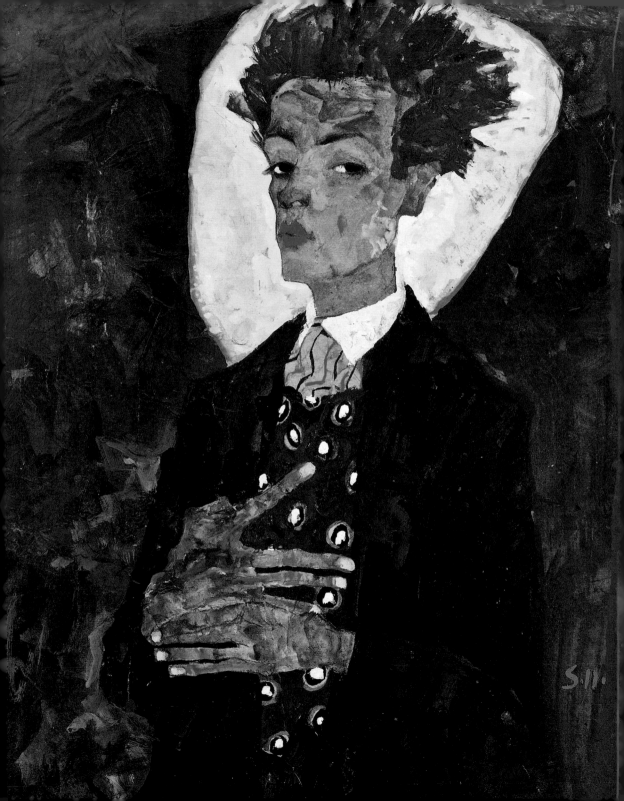

MASTERS OF ART

SCHIELE

Isabel Kuhl

PRESTEL

Munich · London · New York

Front Cover: Self-Portrait with Striped Shirt, 1910

© Prestel Verlag, Munich · London · New York 2020
A member of Verlagsgruppe Random House GmbH
Neumarkter Strasse 28 · 81673 Munich

Prestel Publishing Ltd.
14–17 Wells Street
London W1T 3PD

Prestel Publishing
900 Broadway, Suite 603
New York, NY 10003

A CIP catalogue record for this book is available
from the British Library.

Editorial direction Prestel: Constanze Holler
Picture editing: Stella Christiansen
Translation. Jane Michael
Copyediting: Chris Murray
Production management: Andrea Cobré
Design: Florian Frohnholzer, Sofarobotnik
Typesetting: ew print & medien service gmbh
Separations: Reproline mediateam
Printing and binding: Litotipografia Alcione, Lavis
Typeface: Cera Pro
Paper: 150g Profisilk

MIX
Paper from
responsible sources
FSC® C021956

Verlagsgruppe Random House FSC® N001967

Printed in Italy

ISBN 978-3-7913-8626-3

www.prestel.com

CONTENTS

INTRODUCTION

Egon Schiele was one of the most important Austrian artists of the twentieth century. As a draughtsman and painter, he attempted new subjects and forms of expression that often challenged his contemporaries. He also questioned the social norms of his times and was frequently misunderstood—with regard not only to his creative work, but also his unconventional lifestyle. In the Vienna of the early twentieth century, he was seen as an *enfant terrible*. His exciting and diverse work remains just as topical today.

Egon Schiele was only twenty-eight years of age when he died. It is all the more remarkable to note how extensive his output nonetheless was. He produced some 3,500 works during the twelve years in which he worked as an artist. About one-tenth of these are pictures which he painted on canvas or wood with oil and body colour: most of his works were produced on paper—drawings, watercolours and a few prints. Schiele's drawings are independent works which were discovered by collectors at an early stage. The human figure remained his most important artistic topic, which he explored in particular in his drawings. He pursued this passion in hundreds of sheets, mostly using a pencil and drawing women, men, children, couples—and repeatedly himself.

Schiele is remembered above all for his daring representations of nudes. At the beginning of the twentieth century, he ventured to create images which still create a stir a hundred years later: he presented nudity and sexuality not only explicitly but also without prettifying them. Nonetheless, despite the importance he attached to his erotic artworks, Schiele also turned his attention to other subjects. Townscapes, sunflowers and trees are the main protagonists in his landscape pictures, and they delighted him throughout his life. He also focused on large-format oil paintings with allegorical themes. And he immortalised his family, his fellow artists and his collectors in portraits. He often portrayed himself: he painted or drew over 170 self-portraits during the course of his short life.

No less impressive than the extent of his work is the rapid development which Schiele underwent in just twelve creative years. During his time at the academy he studied above all the ideas of Art Nouveau, known in German-speaking countries as *Jugendstil*. He worked to imitate its Austrian protagonist Gustav Klimt. But before long, when Schiele was just twenty years old, he abandoned both ornamentation and surface, dispensing with the elegant backgrounds and the flowing lines

of *Jugendstil*. In his portraits and nude pictures, he now presented emaciated bodies in an empty picture space, experimenting with grimacing expressions and gestures, gazing with a complete lack of taboos at love, life and death. Together with his compatriot Oskar Kokoschka, during the ensuing years he paved the way for Expressionism in Austria.

One of Schiele's early collectors remembers that he was "not only a fine artist, but a master of the art of living in the full sense of the word"—albeit one who stood with both feet firmly anchored in the art world. At an early stage Schiele established an extensive network of art lovers, collectors and patrons and maintained close contact with them. He participated in a large number of exhibitions in Austria and abroad and kept up a lively correspondence with numerous art associations. Even during his lifetime some of his pictures and drawings were accepted by museums; the first was the Museum Folkwang in Hagen, Germany, followed later by what is now the Belvedere in Vienna.

After Schiele's death his work was initially largely ignored. Like that of most Expressionist artists, his work was defamed during the Third Reich, the Nazis classifying his pictures as "degenerate art". During these years many of his drawings and pictures ended up in America. Only in the second half of the twentieth century was Schiele rediscovered in his native land. Since then he has been celebrated as one of the most important painters of classic modernism.

The thirty-five individual works presented in this book reflect the range of Schiele's creative oeuvre, from elegant Viennese *Jugendstil* to harsh Expressionism, and from rapid pencil sketches to large-format paintings. Portraits which Schiele was commissioned to paint are shown alongside deserted landscapes. Some of the artist's self-portraits are also presented here, Schiele's gaze into the mirror reflecting very diverse images, from the proud artist to the Existentialist nude. After a concise biography, the thirty-five selected works chart the key stages in Schiele's artistic development.

LIFE

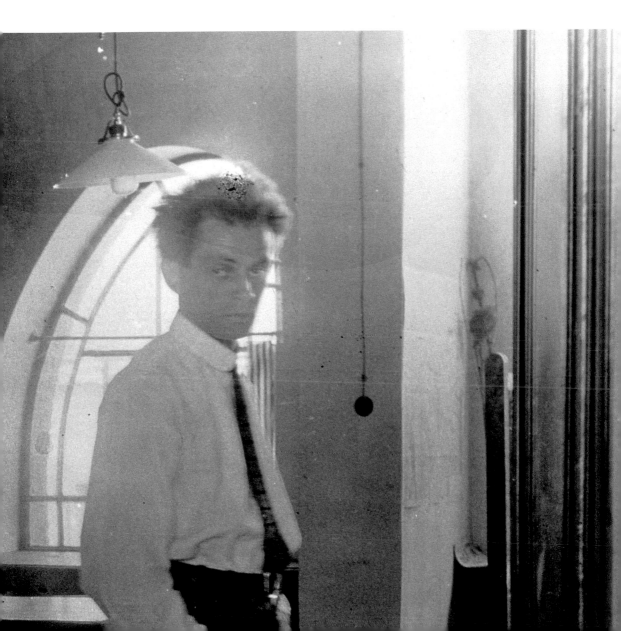

Egon Schiele was born on 12 June 1890 in Tulln, a small town not far from Vienna. He was the third child of Marie and Adolf Schiele and grew up with his three sisters: Elvira and Melanie, who were both older, and Gerti, who was born in 1894. The Schiele family lived in the apartment at the railway station in Tulln to which Adolf Schiele, as the stationmaster and railway official in charge, was entitled.

Egon was fascinated by the railways. His sister Gerti recalled that her brother was able to imitate perfectly the noises the trains made because he spent a large part of the day "in front of the station building, shuffling, hissing, huffing and whistling". He also took up the subject in his drawings: even as a child he sketched everything around him, mostly in pencil. During the early years that included above all trains and rails, crossing barriers and the station building.

Egon loved drawing from the very start, but he found learning at school very difficult. During his first two school years, he was taught by a private tutor, after which he attended primary school, where his marks were at best mediocre. But his parents had very definite ideas: they wanted their son to study for a technical profession. There was no secondary school in Tulln, so when Egon was ten years old they sent him in the first instance to Krems. Egon attended grammar school in the town on the Danube, some forty kilometres from home—but with little success. He even had to repeat a year. In 1902 he transferred to Klosterneuburg, which was nearer to Tulln and where a grammar school had just been opened.

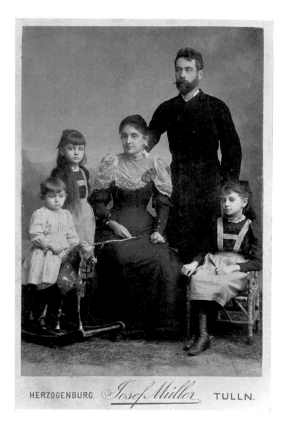

HERZOGENBURG. *Josef Müller* TULLN.

Adolf and Marie Schiele together with the children Egon, Melanie and Elvira, c.1892

Initially he lived in Klosterneuburg at the home of his former tutor; in 1904 the rest of the family joined him in the town.

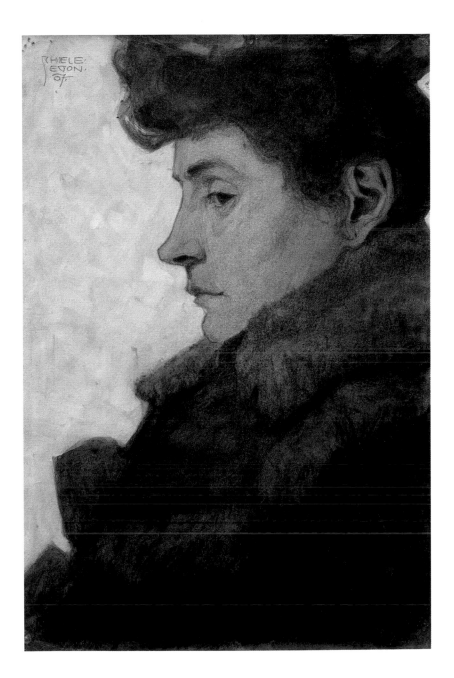

Portrait of Marie Schiele with fur collar, 1907

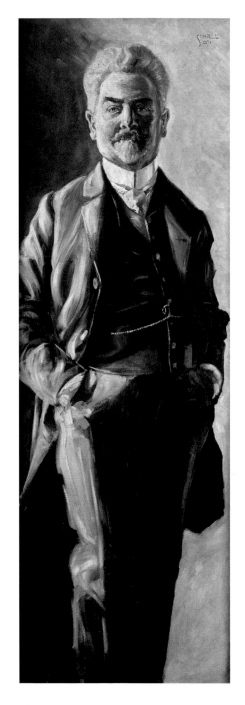

Portrait of Leopold Czihaczek, 1907

Egon's school career at grammar school seemed doomed to failure, and he had to repeat another year. His marks remained abysmal. His talent for drawing continued to be more in evidence than his interest in the other subjects. He spent all his time drawing and explored the landscape around his new home in Klosterneuburg through sketches. And paintings: many of his early pictures are oil studies, mostly on card. In these early works Schiele experimented with a variety of media: he drew with a pencil, sometimes with China ink or charcoal, and he painted with watercolours or pastels. The drawing teacher at Klosterneuburg, Ludwig Karl Strauch, became his first patron.

Egon's father Adolf Schiele died on 31 December 1904. For some years he had suffered from the effects of syphilis; it was claimed that he burned his shares in the railway in a state of mental derangement brought about by the illness, thereby plunging the family into financial hardship. The modest pension that remained was barely enough to live on, and the economic situation of the Schieles deteriorated. Leopold Czihaczek, their father's brother-in-law, was appointed Egon and Gerti's guardian, and he also supported the family financially. A well-to-do engineer from Vienna, Uncle Leopold was enthusiastic about Egon's talent for drawing, but also insisted that his nephew should be admitted to the university. Egon refused to stop drawing, however, and was quite sure where his future lay. From the very beginning he always signed his works, his drawings as well as his paintings, and even the countless portraits in which he depicted the members of his family: he drew his

mother and painted portraits of his uncle. But it was his younger sister Gerti he drew and painted most of all; she was his favourite model for many years and Egon remained very attached to her throughout his life. She herself later recalled the "tough and often tyrannical way" her brother treated her: "He would come to my bed early in the morning with his watch in his hand and would wake me. I was to sit for him as model. I was at his beck and call."

In the meantime, Schiele's school career came to an end: he was eventually so far behind his classmates that he had to leave school prematurely in 1906. Marie Schiele tried to find her son a position as a draughtsman, but without success. Instead, Egon applied to the Kunstgewerbeschule (School of Arts and Crafts) in Vienna, but in view of his remarkable talent for drawing he was recommended to approach the Akademie für bildende Künste (Academy of Fine Arts). He was only just sixteen when he took the entrance examination in October 1906. And passed: "Egon has passed with flying colours", wrote the mollified Uncle Leopold in a telegram to the family back home. Schiele began his training as an artist during the winter term. He was the youngest student at the academy. Vienna became his home city, and the rest of the Schiele family joined him there in 1907.

From the middle of the nineteenth century onwards, Vienna had been transformed into a world metropolis. It was also the cultural centre of the Austro-Hungarian monarchy, and the fourth-largest city in Europe: around 1910, over two million people lived there. The economy was booming and

workers were urgently needed as a result of industrialisation. And they, in turn, urgently needed somewhere to live. Major building projects were soaring skywards in the city centre; museums, the opera house and the university were being built along the new Ringstrasse. The city was also an artistic melting pot. The years around 1900 are described as the "Viennese art spring": in architecture and painting, music and literature, artists were searching for a new, modern language. It was during this time that Art Nouveau, also known as *Jugendstil*, gradually asserted itself in fine art. Developing against a background of industrialisation, the movement found its inspiration in the forms of nature: the tone was set by plant motifs and curved lines, and the design emphasised surface rather than depth.

AM STRAND...

On the Beach, 1907

However, this wind of change did not blow away academic teaching, and so at the Academy of Fine Arts Schiele initially learned Anatomy and Drawing, Theory of Colours, and Perspective; thereafter, the students were also allowed to draw from models. Before long Schiele was rebelling against the curriculum and its rigid methods; his reports were only minimally better than those at school. Increasingly, his life took place outside the academy and he rarely attended classes. He travelled to Trieste with his sister Gerti, and he visited the Secession exhibition in Munich, where he saw many works by modern international artists.

In Vienna, too, a "house for modern art" had recently been opened. The Secession was a new building completed in 1897 just a stone's throw from the academy Schiele was attending. It was here that the Viennese *Jugendstil* artists—painters, architects and craftsmen—exhibited their works. Schiele studied their works and read *Ver Sacrum*—"Sacred Spring"—the Secessionist magazine. And he met Gustav Klimt. The Viennese artist was one of the co-founders of the Secession and was also its first president. He was, moreover, one of the most sought-after painters in the city. Klimt rejected the established history painting praised by the academy, and as a result he—and the other Secessionists in general—were not popular with the members of the conservative academy. In particular, Professor Christian Griepenkerl, whose classes Schiele attended from 1908, was strongly opposed to the art of the Secession. He even banned his students from attending its exhibitions, in which the works of modern artists from abroad were also on view. This deterred very few of them from going to see the works on display, however. In any case, at the Art Exhibition of 1908 Schiele also studied Austrian painting and sculpture as well as crafts such as jewellery, furniture and porcelain. The key theme of the exhibition was the *Gesamtkunstwerk*, the "total work of art", and so all artistic genres were represented. Klimt gave the opening speech and declared the show to be a "review of the strengths of Austrian art". An entire room was dedicated to his pictures; he showed sixteen paintings, including the famous picture *The Kiss*.

Schiele himself also exhibited his works during the same year—at the age of just eighteen. Not in Vienna, however, but in his former home, Klosterneuburg. In 1908 he was invited, together with other painters from the town, to show some of his works in the monastery there. Schiele was the youngest participant. In the years before, he had established initial contacts with the local artists, including the drawing teacher Ludwig Karl Strauch and the painter Max Kahrer. So now he was permitted to exhibit his paintings. But without economic success; Schiele did not sell a single painting, although admittedly he had been decidedly optimistic when setting his prices. He asked as much as 800 crowns for one of the pictures, a considerable sum which even years later he was only able to realise for a small number of his works. Nonetheless, the show in Klosterneuburg did have a positive effect: the doubters in Schiele's own family became quieter, at least temporarily. His mother and Uncle Leopold were impressed.

Schiele received positive mentions in several newspaper reviews. Above all, however, he attracted the attention of art lovers and collectors. Among them was Heinrich Benesch, who would become an enthusiastic collector of Schiele's works over the next decade. However, at the Klosterneuburg exhibition Benesch considered Egon Schiele's works to be still "a poor imitation of Klimt".

Klimt's influence on Schiele was indeed unmistakable during this time. Like his role model, Schiele also experimented with planar representations, elegantly curving lines and geometric patterns. He not only approximated Klimt's style; he also sought to establish contact with the admired artist. Klimt, for his part, invited Schiele to show his work at the International Art Exhibition in Vienna in 1909. Schiele finally exhibited four works, including his portrait of his fellow painter and friend Anton Peschka (pages 40/41). Schiele experimented with Klimt's ideas regarding composition and set a realistic likeness of a figure against a background of ornamentation. Like his role model, he painted with brilliant colours and experimented with silver and gold paint. Schiele even emphasised his evident borrowings from the great star: he told people that he was a "silver Klimt". But at the major exhibitions few critics noticed his works. Schiele himself was impressed by the works of the youthful Austrian artist Oskar Kokoschka, whom Klimt had also invited. In contrast to the *Jugendstil* artist, Kokoschka went beyond the decorative surface of the subject. He distorted figures and forms in order to portray something beyond the physical shell: he was interested in the inner lives of his figures. He approached their bleak souls with a coarse painting technique which not infrequently shocked his contemporaries, thereby becoming a forerunner of Expressionism.

After his excursions into the art world beyond the academy, Schiele's problems with the traditional attitude to art which prevailed there increased. He was not the only one to voice criticism: together with other like-minded students, he expressed open criticism of the academic curriculum for 1909. The reaction followed promptly: the signatories were threatened with exclusion. Schiele forestalled them by abandoning his studies after three years. He did not return to the academy after the summer term, instead pursuing his own plans. Together with artists like Anton Peschka and Anton Faistauer, his colleagues from the academy, the nineteen-year-old Schiele founded the Neukunstgruppe (New Art Group). He compiled a founding manifesto in which he demanded complete creative self-determination for each of the "New Artists". In total contrast to the academic curriculum, the free development of individual talents and ideas took pride of place. The Viennese art dealer Gustav Pisko made the rooms of his gallery available to the newly formed group, so that the New Artists were able to hold their first exhibition in December 1909. They attracted the attention of the art critic Arthur Roessler, who made positive comments about the group, especially about Schiele, whose works were prominently displayed in the exhibition. The following year, Roessler introduced Schiele to his first collectors, including the doctor Oskar

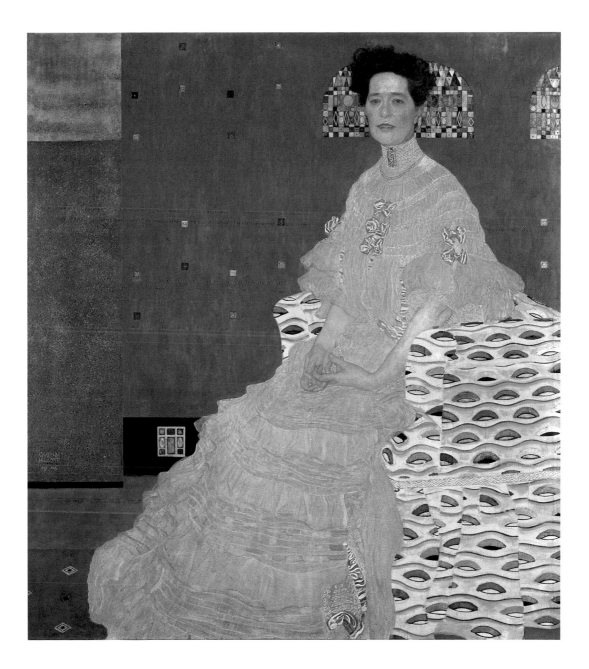

Gustav Klimt, *Portrait Fritza Riedler*, 1906

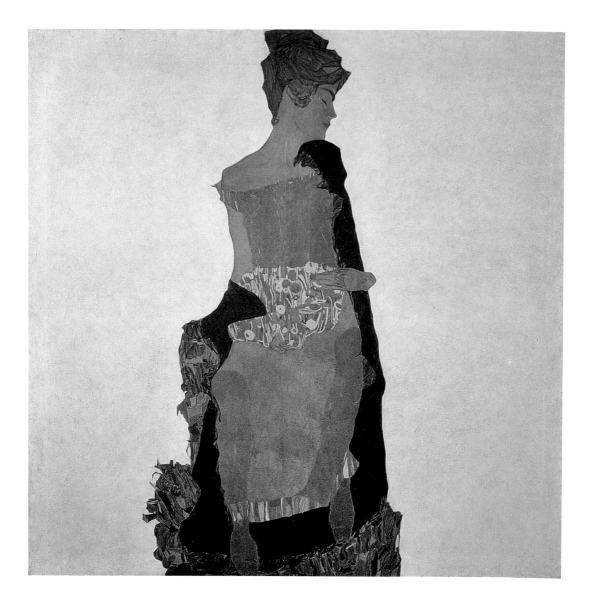

Portrait Gerti Schiele, 1909

Reichel and the industrialist Carl Reininghaus. Both purchased some of Schiele's works and in 1910 commissioned him to paint their portraits.

In the portraits he painted at this time, Schiele had already distanced himself from Klimt. Unlike in his earlier portraits, he left the background empty, adding ornamental details only in small areas, as in his portrait of his sister Gerti from 1909. And it was not only in the composition of the background that Schiele took a new approach. Together with his New Artist colleague Erwin Dominik Osen, during the next year he explored wild, distorted poses which found their way into sketches and portraits. Osen was not only a painter, but also an expressive dancer and pantomime. His unconventional body language pointed the way for Schiele, who recorded it in numerous sketches. He heightened the scrawny body and the wild grimaces of his model through his painting style: hard contours, unnatural colours and stark perspectives. In his self-portraits, too, Schiele experimented with the daring new pictorial language. He showed his body deformed, his facial expressions distorted, his gestures abrupt, as in the impressive *Nude Self-Portrait, Grimacing* (page 21).

Schiele also made the acquaintance of one of the earliest Viennese Expressionists, Max Oppenheimer. For a short while, the two of them worked together; Schiele painted the artist's portrait in several watercolours (pages 52/53). Schiele remained true to his new artistic language, working with sharp contours and bold colours far removed from all natural resemblances. By this time, at the age of twenty, he had already abandoned *Jugendstil* and concentrated on his own expressive style. He also discovered his most important subject: the human figure. *How* he now portrayed people was certainly radical: his figures mostly stand isolated in an open space, their deformed bodies and grimacing faces depicted in wild colours. They seem to turn their innermost being inside out.

These works did not recommend him as a portrait painter for Vienna's exclusive society. His portrait style was not flattering, and his clients were sometimes dissatisfied with the result. Oskar Reichel, for example, commissioned Schiele to paint his portrait, but he then refused to accept it; the publisher Eduard Kosmack also rejected his portrait because he had expected something more distinguished. And the famous architect Otto Wagner even broke off his sittings as model for his portrait; he said it was taking too long, though in fact he found the finished head a success. Such failures did not help Schiele's financial situation, for portrait painting was an important source of income for artists in Vienna; most artists made a living from painting portraits of the well-to-do.

And by now Schiele had his own studio and had to support himself without help. Uncle Leopold, with whom he had quarrelled on a number of occasions, eventually relinquished his guardianship, together with his financial support, of his nephew. Schiele found himself in financial difficulties; he was able to sell some of his pictures, but his lifestyle was extravagant and frequently exceeded his means. Gustav Klimt continued to help him: he introduced his fellow-artist to the Wiener

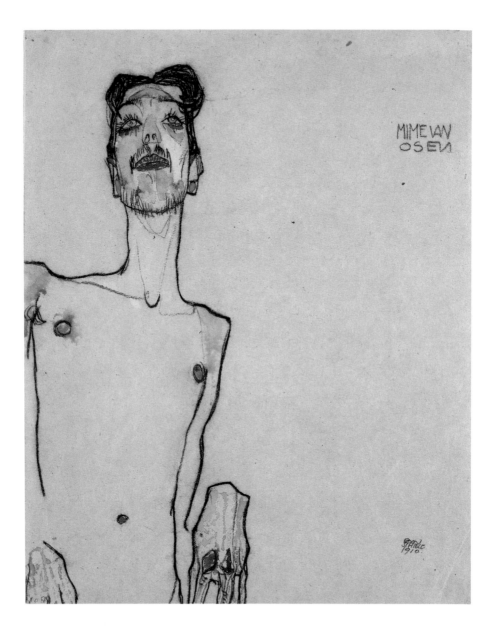

Mime van Osen, 1910

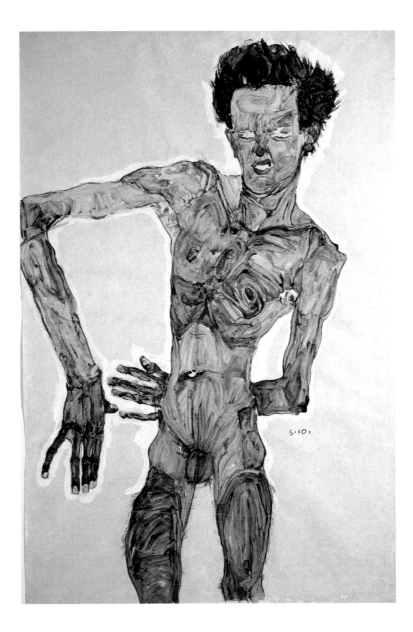

Nude Self-Portrait, Grimacing, 1910

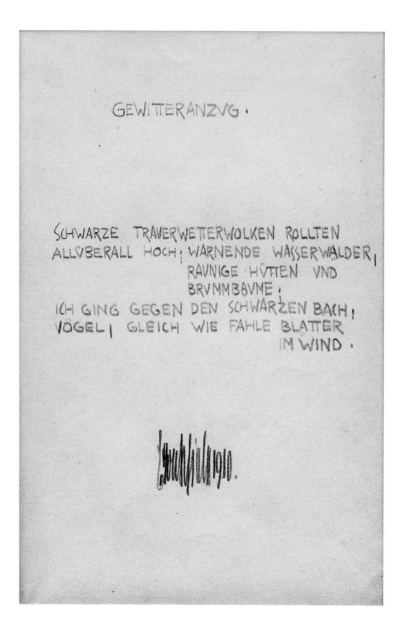

GEWITTERANZVG .

SCHWARZE TRAVERWETTERWOLKEN ROLLTEN
ALLVBERALL HOCH; WARNENDE WASSERWALDER,
 RAVNIGE HVTTEN VND
 BRVMMBAVME .
ICH GING GEGEN DEN SCHWARZEN BACH ;
VÖGEL ; GLEICH WIE FAHLE BLATTER
 IM WIND .

Poem Approaching Thunderstorm, 1910

Egon Schiele and Wally Neuzil, 1913

Werkstätte. Artists joined together under this umbrella term to promote craftsmanship, thereby creating an alternative to mass production. Schiele was commissioned by the Werkstätte to design a number of postcards.

In 1910 Egon Schiele was not only an independent painter, but also a poet whose language was equally creative. He frequently coined new words. In his poem *Unter dem weißen Himmel* (Beneath the White Sky), for example, he writes of "Stubenhockerhäusler" ("stay-at-home cottagers") in a "Windwinterland" ("wind-winterland"). "Trauerwetterwolken" ("mourning weather clouds") threaten in the short poem *Gewitteranzug* (Approaching Thunderstorm). Schiele's poems are written in blank verse and often pay no attention to correct grammatical structure or spelling. He writes words with capital letters, separates scraps of sentences with dashes and strings random sequences of words together. For him, it is more important to express his own world of experience, often filled at this time with melancholy emotions, than to comply with external forms. Schiele's poems are also close to those of the Expressionist artists who placed the world of their emotions and its expression at the heart of their creative work.

Schiele's view of Vienna at this time was equally gloomy. His financial worries did not diminish, and there were disputes within the New Art Group. There was little to keep him in the city. Schiele wrote to his friend Anton Peschka in 1910: "I wish to leave Vienna, very soon. How ugly it is here.—Everybody is envious of me and deceitful; former colleagues look at me with dissembling eyes. In Vienna there is only shadow, the city is black." Schiele also wanted to take up a new topic—he wanted to paint landscapes: "I have to see new things and learn about them, I want to taste dark waters, to see crashing trees, untamed air. I want to look in wonder at mouldy garden fences." He spent the summer in Krumau (present-day Český Krumlov in the Czech Republic), a little town in a picturesque location on the River Vltava, and his mother's home town. Fellow artists visited him there, including Osen and "Moa", a friend who was a dancer and whom Schiele also

drew. However, the landscapes of Krumau and its surroundings appear in his pictures only from 1911, when he once again spent the summer there.

His life in the country was, however, no longer carefree: the inhabitants of Krumau observed the artist with growing suspicion and disapproval. Schiele provided them with good cause for doing so: in May 1911 he arrived together with Wally Neuzil. Wally had previously sat as a model for Klimt, who must have introduced her to his fellow artist that spring. She became Schiele's favourite model. Not only was Wally the model for many of his works; the two of them lived together. A common-law marriage with an artist's model: at the beginning of the twentieth century, living together as an unmarried couple was very daring and was tolerated at most in artist circles. It was not considered socially acceptable. The fact that Schiele was sharing his life with a model shattered the peace within the village, for at the turn of the last century, the reputation of artists' models was scarcely better than that of prostitutes. Quite apart from this unconventional relationship, Schiele also provoked the residents of Krumau with his mode of dress. When painting he wore a sort of caftan, a painter's smock which immediately earned him a nickname, as he wrote to Arthur Roessler: "The children call me the Lord God Painter because I go into the garden wearing this [!] smock; I draw various children and old women, leathery faces, idiots etc."

Schiele often drew children and they frequently visited his house. The greatest disapproval was reserved for his work with nude models. After just three months of living in the country, the young couple packed their bags again, as Schiele reported to Roessler: "You know how much I enjoy being in Krumau; and now they have made it impossible for us: the people simply shun us because we are red. Of course, I could argue against it, even against all 7,000 of them, but I don't have sufficient time." But the villagers were not mainly concerned about Schiele's political views; out in the country, anyone who failed to conform precisely to their petit-bourgeois ideas was "red"—and that also included people who did not attend church regularly.

Wally and Egon left Krumau at the beginning of August 1911, but not with the intention of returning to the city. Instead, they moved to the little village of Neulengbach in the Vienna Woods, some forty kilometres west of Vienna. They settled into a garden studio and started to work again. As had been the case in Krumau, children were frequent visitors: Schiele's preferred models were boys and girls from the neighbourhood who would also sit as models for his nude drawings. The inhabitants of Neulengbach were no less suspicious of this painting practice than the residents of Krumau had been. Schiele's preference for erotic subjects, his relationship to Wally—the new residents certainly did not conform with petit-bourgeois ideals.

Then, in the spring of 1912, the rural idyll came to an abrupt end: Schiele was denounced, his studio searched, and a large number of his nude drawings confiscated. At first, he was held at the district court in the little town, then transferred to

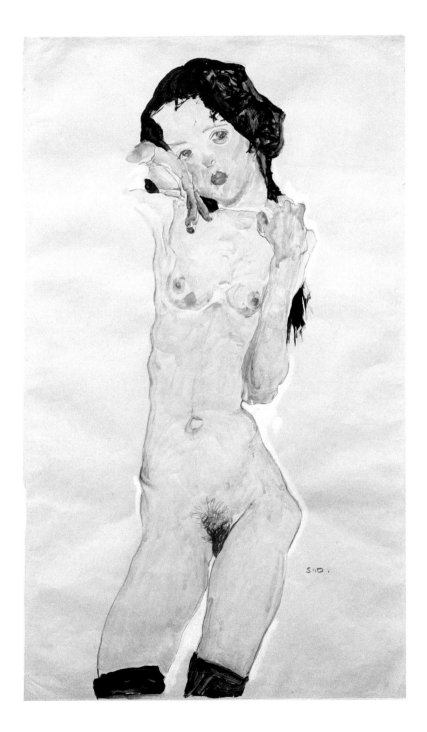

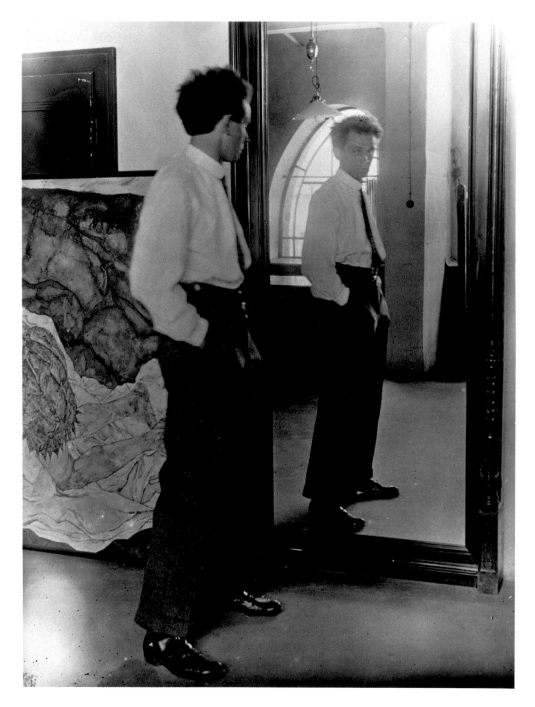

St. Pölten. The charges brought against him were serious: the abduction of children, the violation of a minor, and offences against public decency. Schiele, now aged twenty-one, was brought before the investigating judge on 13 April. During the questioning, which lasted for an hour and a half, Schiele was able to refute the severe charge of abusing a minor. Fourteen-year-old Tatjana von Mossig, whose father had brought the charges against Schiele, had run away from home and had merely sought refuge in Schiele's studio. The other charges, however, remained. Schiele was eventually found guilty of a "breach of public decency" because of an erotic nude picture which hung in his studio and was accordingly on view for all visitors, including the children.

Schiele was deeply depressed as a result of spending over three weeks in prison; following his detention awaiting trial, he spent another three days in custody after sentence was passed. Whilst in prison, he painted twelve watercolours that reflect his fears and loneliness. Initially, he recorded his surroundings: the plank bed, the chairs and the door of the prison cell. Then he painted himself as a prisoner (pages 68/69). He owed the fact that he was able to paint in prison to Wally: she visited him every day, though at first she was not allowed in and they were able to speak to each other only through the barred window. But before long Wally was able to visit her friend and was even permitted to bring him his painting equipment. Schiele commented that Wally had behaved "nobly". After his release, Schiele painted two small oil pictures which can be seen as a double portrait: a portrait of his companion Wally and a a self-portrait in the same format (pages 70–73).

When he was released from prison, Schiele was traumatised. There was no question of returning to Neulengbach after this experience. His friend and patron Heinrich Benesch accompanied him and Wally back to Vienna. Whilst Benesch continued to support Schiele, other patrons were more cautious. Although the Neulengbach affair seems not to have causes much of a stir in Vienna, nonetheless collectors like Reininghaus and Reichel, for example, reduced their support. Schiele could not endure Vienna for very long: he set off on a journey through Austria and to Munich and Zurich, painting a large number of watercolour landscapes on the way. Yet again, he slipped into a precarious financial situation. As a result of the trial and prison sentence, he had lost time which he needed for his work. In addition, he was required to pay the costs of the trial. He wrote frequent letters to his mother, as well as to his friends and collectors, asking for support, but his situation remained difficult.

Nonetheless, the artist had long since established a large network of contacts and had participated in numerous exhibitions in Austria and Germany. He was pleased about his first major exhibition during the spring of 1911, when he and other artists exhibited their works in the Kunstsalon Miethke in Vienna. He became a member of the newly established Sema artist's group in Munich and sent paintings and graphic works to their first exhibition and for the joint portfolio of prints. He took part in exhibitions of the Blue Rider association

in Munich, an association of Expressionist artists. And he also showed his work at the International Sonderbund Art Exhibition in Cologne in 1912 and took part in exhibitions in Dresden and Vienna. Despite the trauma of his imprisonment, it seems to have had little effect on his activities. In the spring of 1913, he was invited to exhibit his works with the Hagenbund, another important artist's association in Vienna.

Schiele's circle was expanding steadily and he showed his work in exhibitions in many cities throughout Europe. Nonetheless, his money problems did not improve, a situation to which his extravagant lifestyle also contributed. Klimt, who supported Schiele where he could, was responsible for a ray of light: he introduced the artist to the Lederers, a family of industrialists. Schiele visited them at the end of the year at their country estate in Hungary and spent the New Year there. August Lederer, the father, was a major patron of Klimt and was also enthusiastic about the works of the young Schiele, purchasing several of them. His son Erich commissioned the artist to paint his portrait and he too became a great admirer of Schiele (pages 78/79).

After his sojourn in Hungary, Schiele settled into his new studio, which he would keep until the end of his life. It was in the Hietzing district of Vienna, where Klimt had previously occupied a garden studio. In January 1913, Schiele was accepted into the Bund Österreichischer Künstler (Association of Austrian Artists) and participated in the association's joint exhibition in Budapest. He also showed paintings and drawings in Berlin and Düsseldorf,

and at the Secession Exhibition in Vienna. And he travelled. Amongst other journeys, he and Wally visited his friend Arthur Roessler, the art critic, at Traunsee in Upper Austria.

It was Roessler who persuaded the Munich art dealer Hans Goltz to show Schiele's works in Munich that summer. However, the hoped-for success was not forthcoming. Goltz noted that he was currently unable to find any buyers for Schiele's works: his drawings were interesting and would probably sell, but the paintings were unmarketable. Goltz's decision not to continue to represent Schiele was a bitter blow for the artist, the more so as his financial position was bleak. By now he had debts amounting to 2,500 crowns with various creditors. In order to understand the magnitude of this sum, by way of comparison: when he was studying at the Academy of Fine Arts, Schiele received five crowns a week from his guardian. His debts were therefore huge. In April 1914 he was even threatened with eviction from his studio flat. Schiele considered finding an alternative to life as an artist, such as teaching or a job with a map maker.

Finally, salvation appeared on the scene during the autumn: via his contacts with the Wiener Werkstätte, Schiele made the acquaintance of the art collector Heinrich Böhler. Böhler booked the young artist as a private teacher, paid for his materials and models, and also paid him a monthly allowance. In addition, Schiele received a number of portrait commissions from Böhler's circle. Schiele was now more optimistic, as he wrote to his mother: "I have the feeling that at last I

DieAktion

WOCHENSCHRIFT FÜR POLITIK, LITERATUR, KUNST

VI. JAHR. HERAUSGEGEBEN VON FRANZ PFEMFERT NR. 35/36

EGON SCHIELE-HEFT. INHALT: Egon Schiele: Selbstporträt (Titelzeichnung) / Professor G. F. Nicolai : Der Kampf ums Dasein / F. A. Harta : Porträt des Egon Schiele / Victor Fraenkl: Von dem Budha zu Mach / Ein unveröffentlichter Brief von Elisée Reclus / Egon Schiele: Studie / Alfred Wolfenstein: Neue Gedichte / Egon Schiele: Das Kind; Mutter und Kind (zwei Federzeichnungen) / Egon Schiele: Abendlandschaft / Wilhelm Klemm: Entsagung / Kurd Adler: Mai-Phantasie 1916 / Anton Sova: Pastorale / Egon Schiele: Studie / Arturo M. Giovannitti: Der Käfig / Egon Schiele: Bild des Malers Harta / Ulrik Brendel und Heinrich Nowak; Ueber Egon Schiele / Ich schneide die Zeit aus / Kleiner Briefkasten / Schiele: Holzschnitt

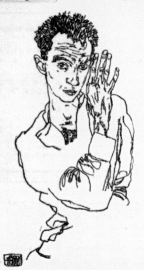

Von dieser Büttenausgabe sind 100 Exemplare gedruckt worden. Dieses Exemplar trägt die Nummer

74

VERLAG · DIE AKTION · BERLIN · WILMERSDORF

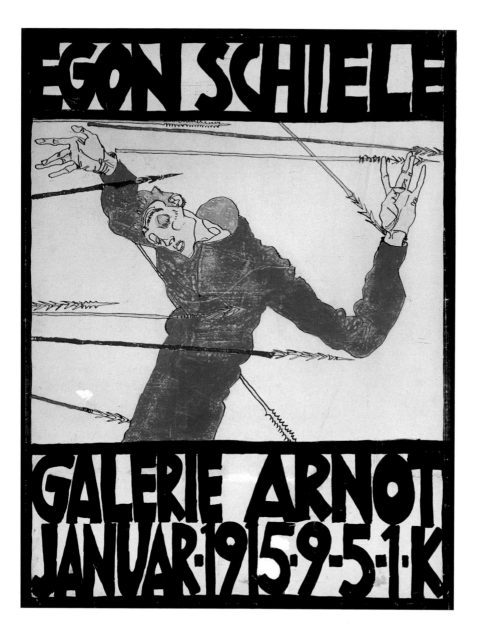

Poster design featuring Saint Sebastian (self-portrait), 1914

Egon Schiele, posing, 1914

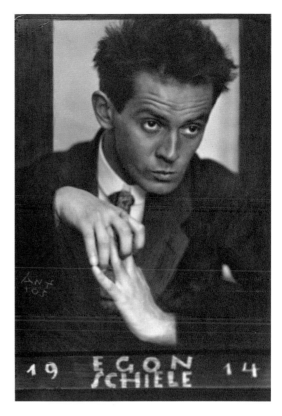

have left my precarious existence behind me."
His poems were also published for the first time
in 1914. Arthur Roessler sent them to the Berlin
magazine *Die Aktion*, an important publication
for Expressionist poetry and graphics. Schiele
repeatedly submitted further works, drawings,
woodcuts and poems. In 1916 an entire issue was
dedicated to him in the form of a special edition.

In the meantime, the First World War had bro-
ken out: on 4 August 1914, Austria-Hungary de-
clared war on the neighbouring country of Serbia.
Schiele, who was small of stature and had suffered
from a congenital heart condition since birth, was
assessed as unfit for military service. But even
away from the front, suffering and death were
omnipresent, with the newspapers disseminating
gruesome pictures of the war. Schiele wrote to
his mother that he was so repulsed by the military
uniforms that he could not even leave the house.
And in any case he was not a patriot; he did not
care in which nation he lived. In November that
year, Schiele described to his sister Gerti how inci-
sive even the first months of the war had been for
him: "We live in the most violent time the world
has ever seen.—We have become accustomed to
all privations—hundreds of thousands of people
are perishing pitifully—and each one must endure
his fate alive or dead—we have become hard and
fearless.—What happened before 1914 belongs in
another world."

Nevertheless, Schiele continued to exhibit his
works as energetically as before; even during the
war years he showed and sold his works in Vienna,
Berlin, Munich and Dresden, and also in Brussels

and Rome. Schiele had his first solo exhibition
at the age of twenty-four, at the end of 1914 and
beginning of 1915. He also designed the exhibition
poster for the show in the Galerie Arnot in Vienna.
On it he showed himself pierced by arrows. It was
a representation that referred back to a popular
motif, the martyrdom of the Roman soldier Saint
Sebastian. Schiele, however, was not alluding to
a religious context, but rather to the sentence
he had received in Neulengbach. After his spell
in prison, he portrayed himself several times in
similar martyr-like roles, as a hermit, a monk and a
preacher (pages 64/65).

Schiele also took up another form of self-
portrait in 1914. He made the acquaintance of the

photographer Anton Josef Trčka and tested the new medium of photography with him: Schiele tried out various baffling poses. Sometimes his own oil paintings are included in the picture, and he presents himself with a wide variety of facial expressions. During this year there arose a whole series of portrait photos that represent another variation on the (self-)portrait: Schiele drew over some of these photographs by hand, colouring and even signing them.

In other respects, too, 1914 was an eventful year for Egon Schiele. He established contact with Edith and Adele Harms, two sisters from the neighbourhood. They both lived with their parents opposite Schiele's studio in Hietzinger Hauptstrasse in the 13th district of Vienna. Letters were exchanged, and they went on excursions and to the cinema together. Schiele's long-standing companion Wally was often part of the group, as chaperone. The parents of the Harms sisters were initially not enthusiastic about their daughters frequenting artists' circles, but in February 1915 the matter seemed settled. Schiele wrote to his friend and patron Roessler: "I am planning to get married—advantageously"; not to Wally, but to the daughter of a good family instead: he had decided that his bride should be Edith, the younger of the two sisters. He separated from his long-standing companion and muse Wally upon the insistence of his future bride. Egon and Edith were married in June; the simple wartime ceremony took place without banns.

On 21 June, just four days after the wedding, Egon Schiele was required to report for military service in Prague. In May, after his third army medical examination, he had now been assessed as fit for service. His wife Edith followed him to Prague, but nonetheless Schiele described the start of his time in the army as "perhaps the most difficult fourteen days of my life". At least he was spared service at the front, not least because he repeatedly asked his influential patrons to intercede on his behalf. He was initially detailed as a soldier on guard duty at military posts around Vienna, but was then sent to more distant locations as well. Edith Schiele followed him wherever possible, but she struggled with the loneliness of life in a foreign place. In the meantime, Schiele had few opportunities for artistic work, especially during the first two years of his military service. The summer of 1916 was an exception: Schiele was stationed at Mühling, a little town in Lower Austria, in a prisoner-of-war camp for Russian soldiers. Allocated to office duties, he also had the opportunity to draw and paint. He depicted his comrades as well as the Russian prisoners of war in pencil sketches and watercolours, and he also portrayed his superiors. He was even able to produce some oil paintings. He created a number of landscapes and committed to canvas the old mill in the vicinity of the town.

In January 1917, Schiele was redeployed, this time back to Vienna. Now, at last, he was able to work in his studio once more. He was commissioned to draw the army stations and camps. In spite of his military service, he was able to return gradually to the artistic life of Vienna, especially as he was redeployed the following year to the

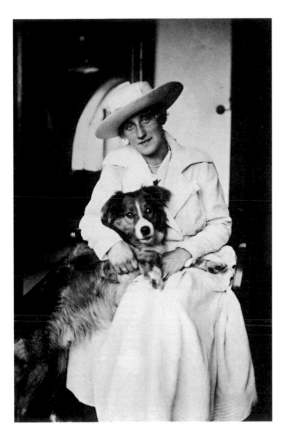

Edith Schiele with Lord, the dog, c.1917

Army Museum in Vienna, where he was to organise exhibitions.

1917 was a productive year for him: in the spring, a first portfolio with prints of his works appeared, followed by art postcards. Schiele once more became involved in the organisation of exhibitions, bringing artists together and expanding further his already extensive network. Together with Gustav Klimt, Arnold Schönberg (a painter as well as composer) and other artists, he participated in the project to develop a "hall of art". Schiele imagined an artists' group in which the art of Austria would counter the horrors of war; a "spiritual gathering place" which would "offer painters, sculptors, architects, musicians and poets the opportunity of establishing a connection with a public which is prepared to defend itself against the progressive advance of cultural decay". Although the hall of art was never built because of a lack of funds, the war exhibition at the Prater in Vienna did take place, and Schiele, together with the painter Albert Paris Gütersloh, was responsible for the selection of the artworks. He also participated with his own pictures. His painting method had changed in the meantime: Schiele's pictures moved closer towards reality. He portrayed landscapes and figures more realistically, and his Expressionist painting style became less pronounced.

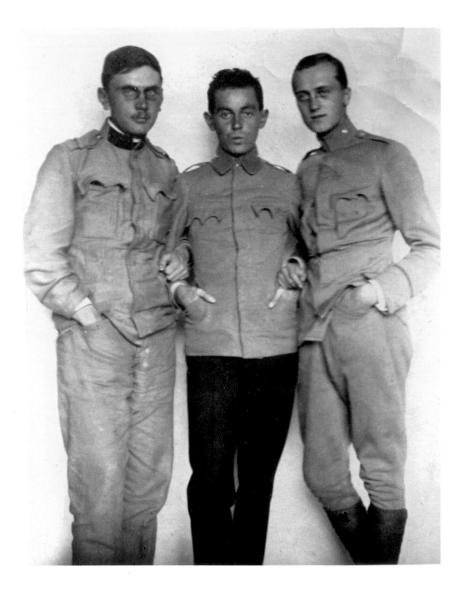

Egon Schiele with two comrades, 1916

In the meantime, another collector entered the stage, Franz Martin Haberditzl: the new Director of the Staatsgalerie in Vienna, the present-day Belvedere, purchased several of Schiele's drawings in the spring of 1917. In the following year he also purchased a large oil painting, a portrait of Edith (pages 102/103)—a great success for Schiele, who hoped that he would see one of his paintings hanging in the Staatsgalerie. The artist also continued to show his works abroad: he participated in the Secession exhibition in Munich and presented works in Amsterdam, Copenhagen and Stockholm.

Schiele's star seemed to continue to rise in the art firmament: in the autumn, the Vienna Secession contacted him. First, they invited him to become a member, then they commissioned him to organise their next exhibition—the 49th in the series. Schiele threw himself into his work and successfully engaged the artists who were to take part. They included a large number of painters from his circle, such as Anton Faistauer, his former colleague from the New Art Group, together with Gütersloh and Schiele's friend and brother-in-law Anton Peschka. Schiele wrote to the latter that in January there were "already so many pictures in the Secession that we could fill three buildings of that size".

In February, Gustav Klimt, one of the founders of the Secession, died during the preparations for exhibition; he had failed to recover from a stroke. Schiele made a drawing of the deceased artist and published his work together with an obituary:

"Gustav Klimt
An artist of incredible perfection
A man of rare depth
His work was sacred."

By agreeing to join the Secession, Schiele was now to some extent accepting Klimt's legacy: at the 49th annual exhibition, which opened in March 1918, Schiele was the focus of attention. The main room of the Secession was dedicated exclusively to his works, and he also designed the exhibition poster (pages 104/105). The show, at which he presented nineteen large paintings and twenty-nine drawings, marked his breakthrough. Artistically and financially, the exhibition was a major success, and the newspaper critics were positive in their reviews of his work. The *Wiener Abendpost* noted that Schiele was now, "almost without knowing and wanting it, the leader of our Viennese Modernism".

The successful Secession exhibition fundamentally changed Schiele's position: his financial worries faded away, he received enquiries about pictures, and the number of his collectors grew. Although he had to continue his war service in the Army Museum, Schiele found time for new commissions. The portraits he painted included that of the doctor and physicist Hugo Koller. The latter's wife, the artist Broncia Koller, had purchased a landscape by Schiele at the Secession exhibition. In July, Schiele moved into his new studio in the Hietzing district of Vienna, an entire house with space for both living and working. The Schiele family needed more space in any case because

EGON
SCHIELE 27.X. 1906.
28. Oktober 1918.

Edith Schiele, 1918

Edith was expecting a child. A productive and creative period began for Schiele; models came and went, he worked on a series of large-format paintings, and participated in exhibitions in Zurich and Prague. He already had plans for his old studio; he was considering opening a painting school there.

That autumn, the end of the First World War was approaching and for many people daily life was very hard. Even the citizens of Vienna could endure no more: there had been a shortage of food and coal for a long time, and the cold winter weather arrived early. When the influenza epidemic raged across Europe, it met with little resistance. Within a few months, the Spanish Flu, so-called because it was first reported in Spain, took its toll of more victims than died during the entire four years of war. Schiele's wife Edith, who was six months pregnant, became ill and died during October. Schiele drew her once more shortly before her death. By that point he, too, had fallen ill. Egon Schiele died on 31 October 1918, just three days after his wife. He was twenty-eight years old. His last words were reportedly "The war is over and I must go."

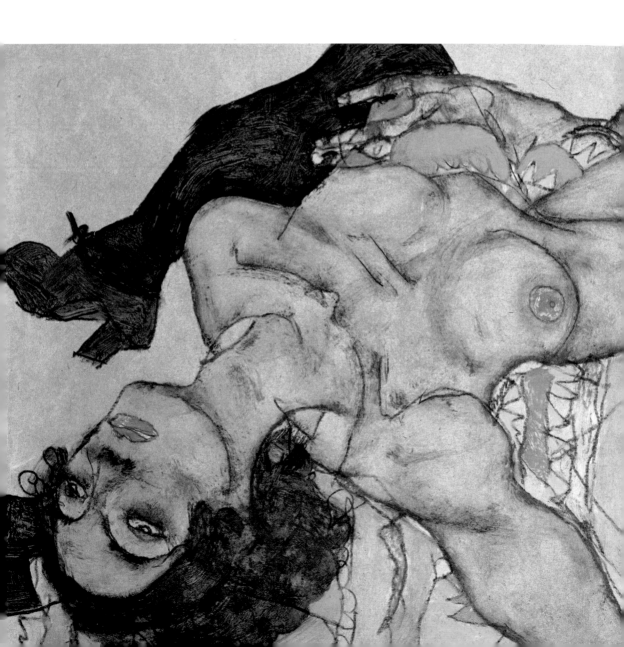

WORKS

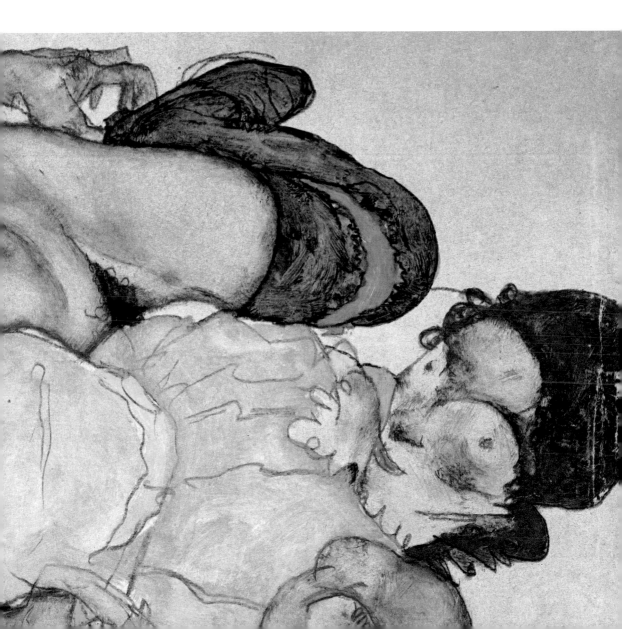

Portrait of Anton Peschka, 1909

Oil and metallic paint on canvas
110.2 × 100 cm
Private collection

Egon Schiele and Anton Peschka, who was five years his senior, were friends. They had met as students at the Academy of Fine Arts in Vienna. However, they both despaired at the approach to art that prevailed there; in the eyes of the young artists the old traditions, to which many professors still firmly adhered, were incompatible with contemporary art.

In 1909, when Schiele painted this picture, he and Peschka had left the academy and founded the New Art Group (Neukunstgruppe) with other artists. Schiele's declared role model at that time was Gustav Klimt, a painter who was not popular at the academy, but who was one of the most sought-after portraitists in Vienna. In his portraits, Klimt concentrated on the face and hands, which he depicted almost naturalistically. But in his paintings the entire background—clothes, wallpaper, furniture—became a surface covered with patterns, flowers and gleaming metallic ornaments. Schiele adopted this approach in his compositions.

He shows Peschka in profile, seated in an armchair. He reproduces the face and hands in particular in a realistic manner, while the rest of the portrait remains two-dimensional. The pictorial design, the colours and his experimentation with metallic paint are all clearly borrowed from his mentor Klimt. Schiele even referred specifically to his proximity to his great role model by describing himself as the "silver Klimt". The "golden Klimt" in turn invited him to show his works at the International Art Exhibition of 1909 in Vienna. This portrait was one of the works which Schiele presented at the exhibition.

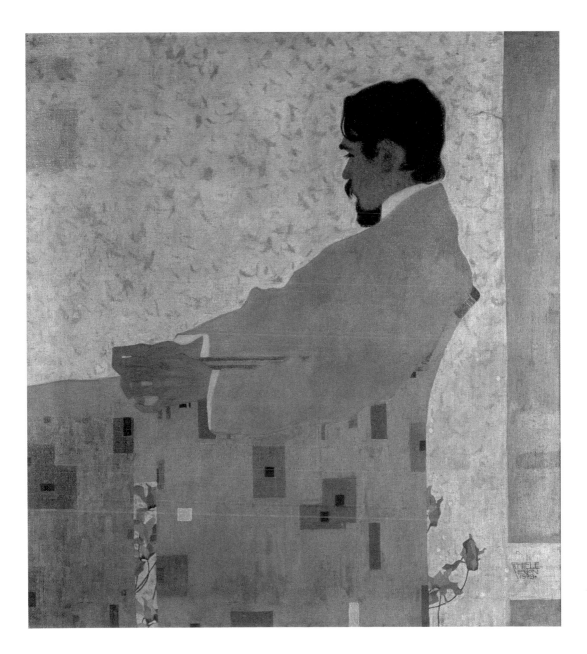

Self-Portrait with Striped Shirt, 1910

Black chalk, watercolour and gouache on paper
44.3 × 30.6 cm
Leopold Museum, Vienna

Heinrich Benesch was one of Schiele's first collectors. He discovered the artist in 1910—also the year in which this self-portrait was produced. Benesch recalled later: "Schiele was unusual not only as an artist but also as a person. He was basically serious by nature; not with a gloomy, melancholic, head-hanging earnestness but with the calm seriousness of an individual fully occupied by his intellectual mission. Everyday matters could not trouble him; his gaze was always focused beyond them, set on his higher aim. At the same time, he also had humorous tendencies and was fond of a joke [...] Schiele's cheerful tranquillity was unwavering; he did not lose it even in the most difficult and unpleasant situations in his life."
Another characteristic that Schiele never lost was his interest in portraying himself. He worked repeatedly on his self-portraits: mostly as drawings, which not infrequently also found their way into a painting, but also in photographs. We know of over 170 self-portraits; most were produced in front of a mirror. In the early ones, Schiele is a youth with almost child-like features; in later ones, he drew himself together with his wife Edith. In these likenesses he sometimes appears to dissect himself and presents himself with grimacing expressions and contorted poses.
It is rather the "calm seriousness" which Benesch attributes to him that speaks in this self-portrait now in the Leopold Museum in Vienna: Schiele has turned slightly forward from the profile view, so that he can gaze thoughtfully at us with both eyes. As in many of his works, here, too, he employs the yellowish colour of the drawing paper like an expanse of colour, while he has used watercolours to paint the head and arms in colour. He shows restraint with regard to the shades used on the upper torso, only hinting at it with a few dark lines.
When Schiele drew this impressive portrait, he was only twenty years old, but he had been quite certain of his own future plans for a long time: he declared that his artistic training at the academy was over as he set up his first independent exhibitions.

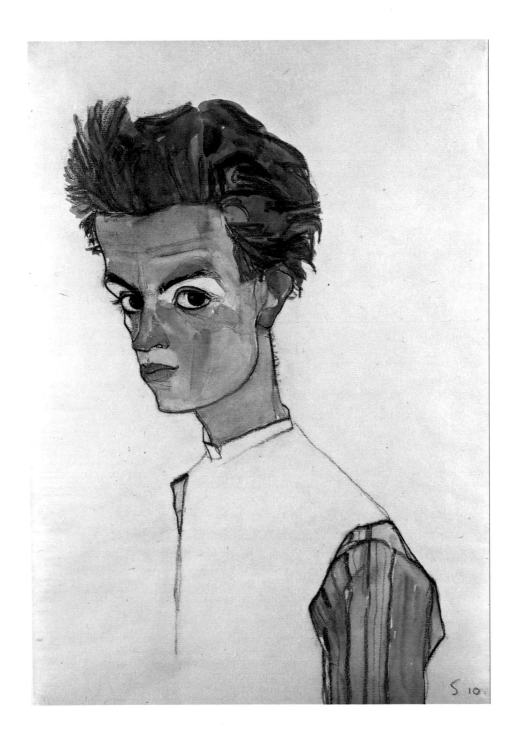

Portrait of Arthur Roessler, 1910

Oil on canvas
100 × 100 cm
Wien Museum, Vienna

The art critic Arthur Roessler discovered Schiele at the exhibition of the New Art Group in 1909. He wrote a detailed review of the show in the newspaper *Arbeiter-Zeitung*, for which he worked as a critic: "Some of them will fall by the wayside, but I consider some of them to be mentally and physically strong enough to 'survive'. Among these I count the extraordinarily talented Egon Schiele, Toni Faistauer, Franz Wiegele, Hans Ehrlich, [...] all those I have named have an astonishingly pronounced feeling for style."

From then onward Roessler accompanied Schiele's career enthusiastically and promoted him wherever he could: either with positive reviews, advice in business matters, or by establishing contacts with collectors. Schiele and Roessler became friends; the critic also purchased a number of drawings by the young artist, and commissioned Schiele to paint this portrait.

The square canvas shows Roessler in a dark suit sitting against a bright, empty background. He is lost in his own thoughts, his eyes closed. He has turned his head noticeably towards his left side, while his body is turned in the other direction. This creates a tension in the figure which is emphasised by the bent arms and outstretched hands.

This was to become Schiele's style. He portrays the body in fragmentary fashion. Here he cuts off Roessler's legs abruptly at the bottom edge of the picture. Before long he would dispense entirely with the design of the background. Here, too, he provides no points of reference; he does not even record the chair on which Roessler is sitting. His sole concern is the inner life of the sitter. Schiele's portraits of 1910 thus mark a turning point in his creative work as he moved on from *Jugendstil* (Art Nouveau) to Expressionism.

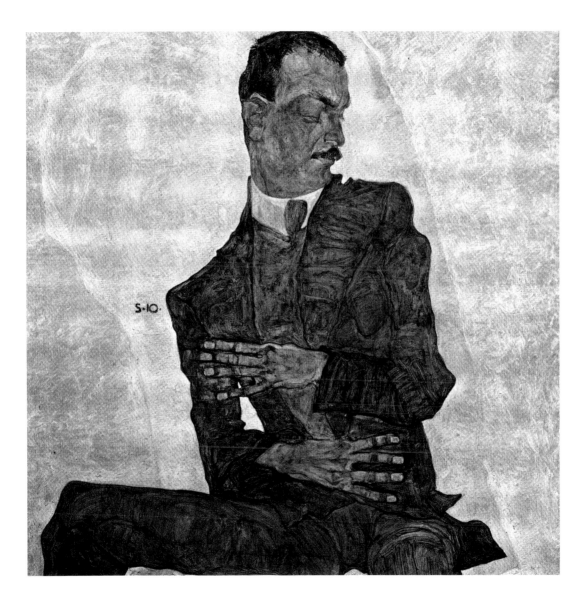

Seated Male Nude
(Self-Portrait, also: The Yellow Nude), 1910

Oil and gouache on canvas
152.5 × 150 cm
Leopold Museum, Vienna

Measuring 150 cm square, this drawing of a nude is so huge that the figure is only slightly less than life-size. Schiele created a total of five of these enormous nudes in 1910, portraying himself on three occasions and his sister twice. This series of self-portraits represented a new venture for him. Male nudes are in any case a less common subject than their female counterparts, but to combine a nude representation with a self-portrait was a daring venture. Works like these alienated Schiele's contemporaries, especially as he did not hesitate to depict ugliness: here he portrays his body like a sequence of abstract forms whose colours moreover make the viewer think of decay.

Background? There is none. Schiele presents his naked body without any form of decoration in a completely empty picture space. This radical likeness is far removed from his *Self-Portrait with a Striped Shirt* (pages 42/43) although they were both created in 1910. Here, however, all narrative elements have disappeared. The emaciated body remains fragmented: the splayed-out legs appear to have been cut off, and Schiele dispensed entirely with the feet. His head is turned to one side and his arms are wrapped around his neck and head. The left eye, nipples and navel are bright red. The harsh outline records the angular bones while the various body parts are distinguished from each other through colour. The greenish colours give the figure a morbid air.

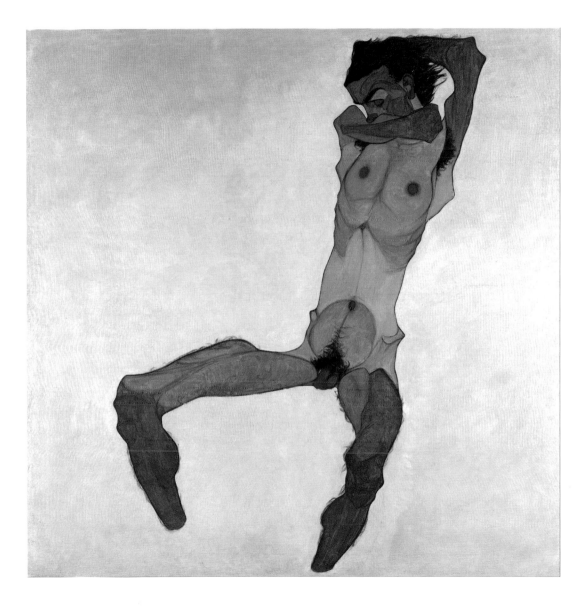

Female Nude, 1910

Pencil, black chalk, brush, watercolour, body colour
and opaque white on packing paper
44 × 30.5 cm
Albertina, Vienna

Schiele was twenty years old when he discovered the nude as a new subject for his pictures. Apart from self-portraits in which he depicted himself in the nude, from 1910 drawings of the nude became a main focus of his work. Hundreds of sheets show how he repeatedly investigated the human body. As Schiele explained to his student Silvia Koller: "The figure—the human body—is the most important thing and is what satisfies me the most."

The nude has been a subject in art for centuries. However, artists have generally portrayed the female or male body as flawless and in an idealised manner, and the pubic area is usually elegantly covered. Schiele's nudes are far removed from this traditional concept. And at the same time they also go beyond realistic representation.

Schiele shows naked bodies in yellow, green or red. And they are fragmented: for example, the legs of this female nude with a shock of red hair have been cut off, together with her right arm. Along with the reddish colours and the austere contours, the artist also uses opaque white to add emphasis to the contours – Schiele's nude has very little to do with romanticised beauty. He is interested less in the tender eroticism or seduction with which his contemporary viewers were familiar from nude representations, but rather in a very open sexual presence. His subjects not infrequently even gaze directly at the visitor.

So that he could draw them, Schiele's models posed for him standing, sitting lying. He frequently sketched his sister Gerti, but professional models and girls from the street posed for the daring erotic nudes. Schiele also found another source of subjects in 1910: he made the acquaintance of a gynaecologist from the University hospital in Vienna who introduced him to some of his patients. Many of the women whom the artist portrayed were pregnant.

Schiele's drawings shocked his contemporaries. He had now totally abandoned the elegance and beauty of the *Jugendstil* (Art Nouveau) which characterised his earlier works.

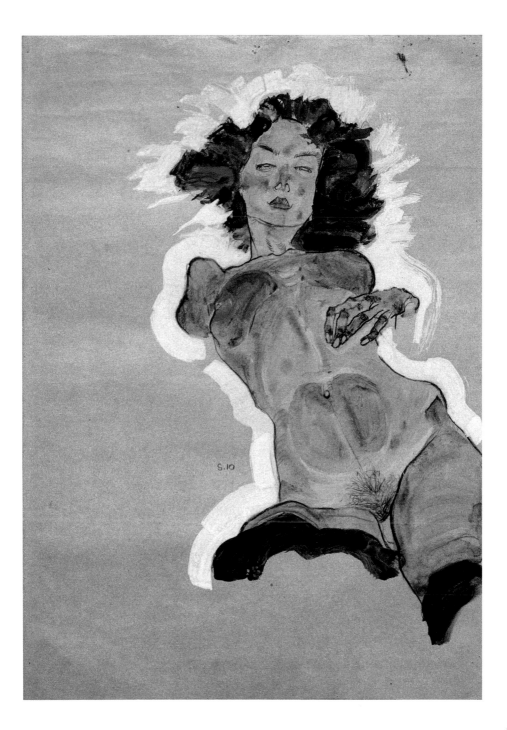

Dead Mother I, 1910

Oil and pencil on panel
32.1 × 25.7 cm
Leopold Museum, Vienna

Schiele regarded the little oil painting *Dead Mother I* as one of his most important
works. In both his pictures and his poems, he frequently studied the cycle of growth
and decay. The fact that life and death lie so close to each other in Schiele's works
may perhaps be due to the fact that he himself was confronted with death at an
early age: his sister Elvira died at the age of ten when he was just three years old;
and his father too died when Schiele was still quite young.
The theme of motherhood is also of considerable significance in Schiele's pictures.
In the spring of 1910, he had an opportunity to draw the patients in a women's
hospital. It was during this time that he produced a large number of drawings
and pictures of mothers with their children and pregnant women. On a number of
occasions Schiele took up the connection between birth and death: at the beginning
of the twentieth century, the mortality rate amongst infants and mothers was still
high.
Schiele himself explained to Roessler how the work had been created: "The
picture 'Dead Mother' [...]—like others covering a related topic—did not arise out
of intentional caprice or meditation, but out of a very sudden inspiration which
I found compelling, in other words I could say, spontaneously as it were [...] in
some pictures the transfer from idea to representation even took place against
my will. [...] Anyway, I beg you to believe me when I assure you that I do not paint
'preposterous' pictures in the interests of some sort of cheap, scary effects."
Arthur Roessler remembered later how Schiele painted the picture within a few
hours on 24 December. He purchased the little oil painting himself and encouraged
Schiele to paint more small-format paintings on wooden panels like this because
they would sell well.

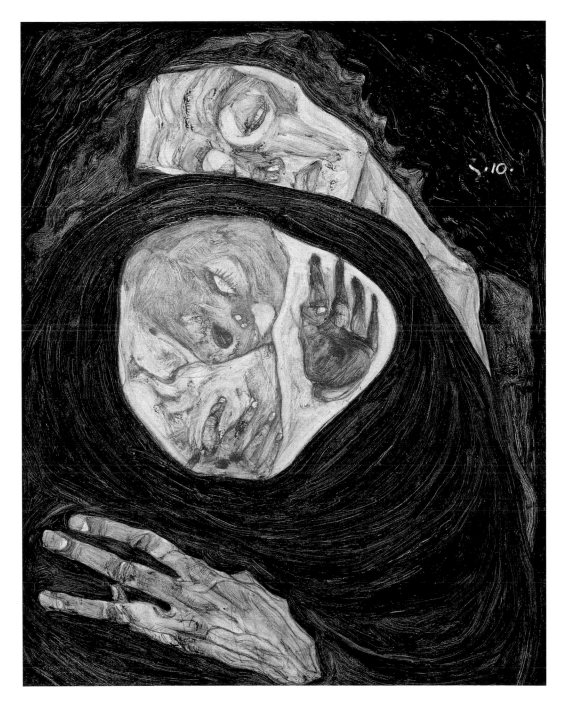

Portrait of Max Oppenheimer, 1910

Black chalk, China ink and watercolour on packing paper
45.1 × 29.8 cm
Albertina, Vienna

In 1909 Schiele made the acquaintance of the painter Max Oppenheimer. At this time Schiele was still strongly influenced by *Jugendstil* (Art Nouveau). Mopp, as Oppenheimer called himself, was five years older and pursued his own artistic ideas; he was one of the earliest Expressionists in Vienna. He participated in the exhibitions of the Vienna Secession and in the International Art Exhibition of 1908, which also made a deep impression on Egon Schiele. When the two artists met the following year, Schiele was still searching for his own means of artistic expression. Oppenheimer nonetheless found Schiele's works interesting: his own approach to painting was different, as he explained to his younger colleague, but he was impressed by the intensity in Schiele's paintings. Schiele suggested to Oppenheimer that they should share a studio, and so in 1910 the two artists worked side by side for several months. They also painted each other, and Schiele portrayed Oppenheimer in several watercolour sketches.

Schiele took a vast leap forward in these sheets. He abandoned the decorative ideas of *Jugendstil* and discovered his own expressive style. This was also the case in the drawing in the Albertina. Here the figure of Oppenheimer, dressed in black, stands out clearly against the empty background. The viewer is disturbed not only by the bare picture space, but also by the composition. Oppenheimer's angular gestures seem to burst out of the frame. The painter's legs and his right arm are cropped by the edge of the picture, while he is holding his bony left hand in front of him at chest height. As in earlier portraits, Schiele restricts himself to the face and hands in his use of colour. However, the yellowish-greenish shades which he chooses here are far removed from all natural representation, especially as the brushstrokes can be clearly seen.

A comparison with the portrait of Schiele's painter colleague Anton Peschka (pages 40/41), whom he had painted one year previously, shows the rapid development to a completely new and radical form of representation. With these works Schiele has freed himself from the influence of his great role model Gustav Klimt.

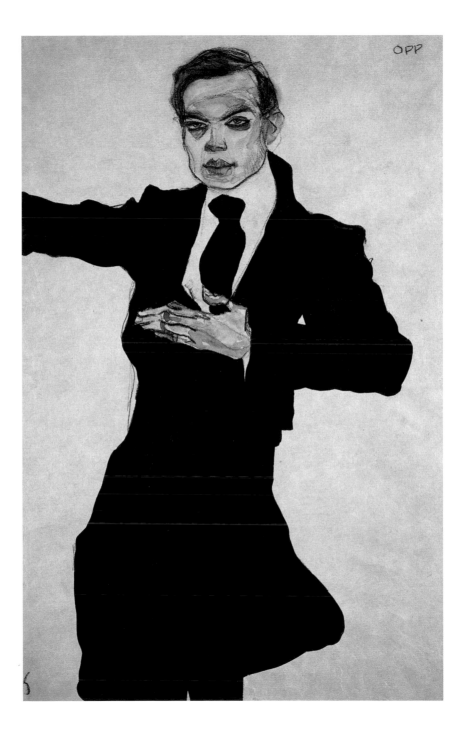

Schiele with Nude Model in Front of the Mirror, 1910

Pencil on packing paper
55.1 × 35.3 cm
Albertina, Vienna

"His drawing skills were phenomenal. The sureness of his hand was almost infallible. When drawing he mostly sat on a low stool with the drawing board and sheets of paper on his knees; his right hand, with which he drew, rested on the support. [...] If he made a mistake, which was very rarely the case, he would throw the sheet away; he never used an eraser. [...] Schiele always made his drawings after nature. They were essentially outline drawings which only acquired greater plasticity through colour."

We can understand a little of what Heinrich Benesch wrote about the artist he so admired through this masterly pencil drawing. It shows Schiele at work— incidentally, this is the only occasion on which he drew himself actually drawing. He is sitting in front of the studio mirror (which, however, we cannot see) and he has a drawing board on his knees. In front of him stands his model with her back to him: the young woman is naked except for a hat and stockings. She placed has one leg in front of her and she has her hand on her hip. On the left-hand side of the sheet, Schiele shows us himself and his model in front view—in other words, the view reflected in the mirror. On the right-hand side he has recorded the back view of the young woman before him. At first sight the viewer thinks that Schiele has drawn three figures. That is because he does not show the mirror—as, indeed, he omits any reference to the studio. He has shown neither the room, nor the stool on which he sits to draw, nor the large studio mirror in front of which the model is standing.

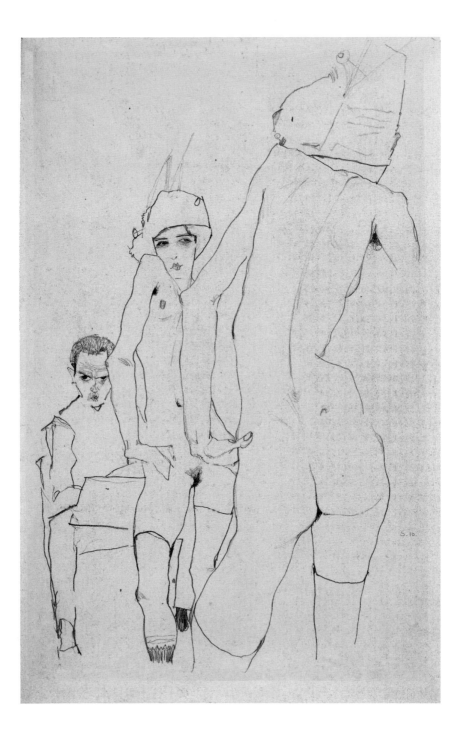

Self-Portrait with Peacock Waistcoat, 1911

Blue chalk, watercolour, body colour and tempera on paper
51.5 × 34.5 cm
Collection of Ernst Ploil, Vienna

Schiele repeatedly pointed out how hard his life as an independent artist was, and lamented his permanent financial worries. As a result of this poverty, he even wore the old clothes of his guardian, which was why his hats and shoes were always too big for him. With his wild hair, he certainly did not look like a nice young man. This self-portrait from 1911 tells a different story, however—but it is unusual in a number of respects.

It is surprising that here the artist should look so elegant. He is wearing a smart suit with a fine waistcoat and cravat. His head erect, he has a slightly arrogant look as he gazes at the viewer. There seems to be no sign here of the money problems he mentioned so frequently. And there is certainly no doubt about Schiele's confidence in himself as an artist; after all, he has even painted himself with a sort of halo. What is more: this time Schiele, who otherwise did not waste time painting backgrounds, has filled the sheet completely. In fact, this coloured drawing looks almost like a painting.

It is also interesting to note in this context how the actor and painter Paris von Gütersloh described his friend after the latter's death. He said that Schiele did not look in the least like an artist: "no long hair, never unshaven for even a single day, never with dirty fingernails, and even in his poorest days never in a wretched coat. He was—and that is now not just the embellishment of my memory—an elegant young man whose good manners were strangely the exact opposite of his supposedly bad manners as a painter, at least at that time and for that time."

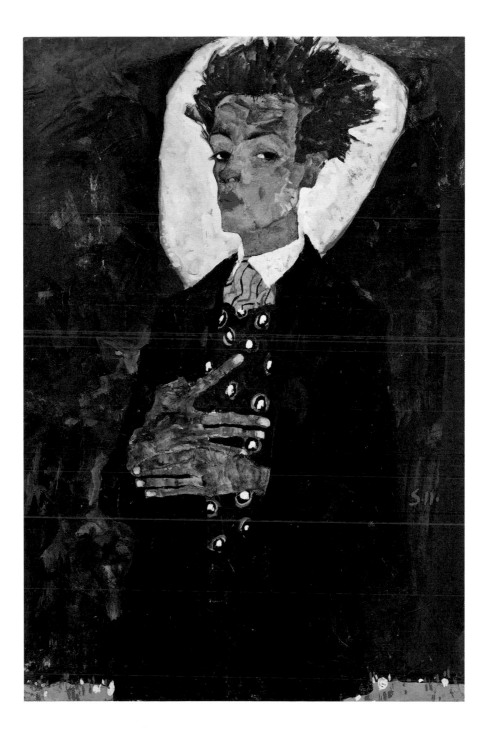

Two Women Embracing, 1911

Watercolour and pencil on paper
56 × 37 cm
Private collection

Schiele's drawings often showed very daring subjects. He depicted couples
during love play, sketched girls masturbating and drew same-gender couples.
In Schiele's day, homosexual love, both male and female, was prohibited and
outlawed by society. Schiele ignored such taboos. In fact, his nudes disturbed
the public because of the unusual perspectives and views of exposed genitalia.
Not infrequently, the women or girls whom Schiele drew gazed directly at the
viewer—and that, too, unsettled his contemporaries.
When Schiele drew his first nudes, he was just twenty years old. And yet he already
had a ready answer to the hypocritical sexual morality of his age. At that time,
sexuality was only accepted as long as it remained invisible. Visiting prostitutes was
common practice in Vienna at the turn of the century, but it had to remain secret.
It was the Viennese physician-psychoanalyst Sigmund Freud who helped to bring
this socially prescribed suppression to light. His insights into the human psyche,
our emotional lives, our subconscious and our suppressed drives were a keen topic
of conversation in more enlightened circles. His writings certainly had a profound
influence on artists. "Even erotic artworks are sacred!" wrote Egon Schiele 1911
to his Uncle Leopold. Schiele's friend and patron, the art critic Arthur Roessler,
once put it thus: "Those who see only nudity in Schiele's artworks, only obscene
nakedness and nothing else, are beyond help …"

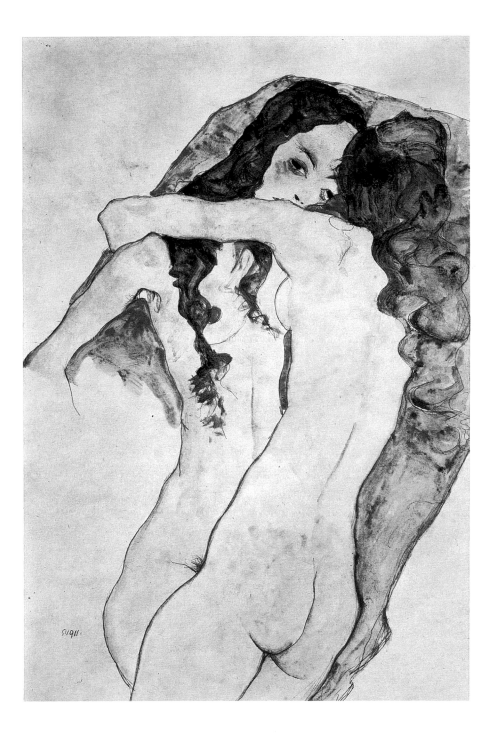

Girl in Ochre-Coloured Dress, 1911

Pencil, black chalk on Japan paper
48.2 × 32 cm
Albertina, Vienna

As later recalled by his painter friend Paris von Gütersloh, in Schiele's studio there were always "two or three small or larger girls from the neighbourhood, from the street, whom he had spoken to in nearby Schönbrunn Park, ugly and pretty ones, clean ones and others who were unwashed, and [who] sat around in his studio doing nothing [...] They slept, recovered from beatings by their parents, lolled around lazily, which they were not allowed to do at home, combed their hair quickly or somewhat longer, depending on whether it was short or tangled, pulled their skirts up or down, tied or untied their bootlaces."

Children wandered in and out of Schiele's studio in Vienna: during his sojourns in the country in Krumau and later in Neulengbach, he drew children from the neighbourhood on countless occasions. Sometimes his preferred technique was to use watercolours. In 1911, for example, he mostly worked with water-soluble paints which flow over the paper and do not cover it very densely. As a result, the paper on which Schiele was drawing continued to shine through. Mostly he simply placed the children, like his figures in general, on an empty sheet of paper. He provided no details about the space around them. This is also true of the girl in the yellow-ochre dress gazing at us earnestly with her big, dark eyes and her hands folded. The child is probably sitting, but Schiele does not even tell us that much. He concentrates entirely on the people he is portraying. And as in his portraits of adults, Schiele does not prettify the children's likenesses in any way. The girls and boys he draws have dirty hands or marks on their faces; they are quite often shown wearing torn clothing. Only a few of them look happy or playful.

Schiele's contemporaries were suspicious of the fact that he drew children in the first place, all the more so because he sometimes showed them half-naked. Even in Vienna he created a scandal which his artist colleagues warned him about. It would not be long before their concerns were confirmed.

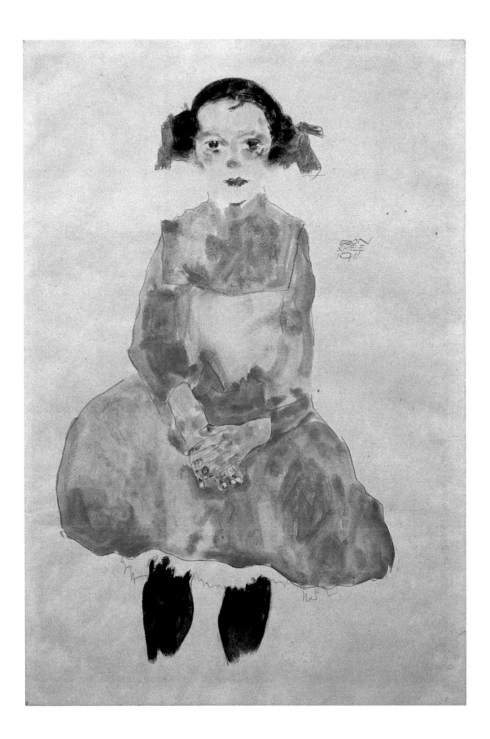

Half-Dressed Girl Lying Down, 1911

Pencil, watercolour and gouache, heightened with white
45.9 × 31.1 cm
Albertina, Vienna

Schiele's nudes are unusual in many respects. This starts with the format: classical nude representations show lying women, and less frequently men, as horizontal-format pictures. Schiele, by contrast, often decided on a vertical-format portrayal. Sometimes he turned the sheet of paper while he was working, thereby changing the perspective. In 1911 he started to turn his figural representations through 90 degrees—or even showed them upside-down. Accordingly, he drew the lying figure as a horizontal format, but then turned the paper so that the position of the figure in the space is ambiguous. At the same time, however, he signed his sheets as vertical formats, thereby laying down the direction in which they were to be viewed. Schiele often drew from an elevated position. He would either sit on his stool or even look down from a ladder at the model sitting or lying on the floor. This perspective produced interesting compositions; some of his figures look as if they are falling or are suspended in space. Schiele drew these sketches rapidly in pencil, and during a session with a model he would create a number of such drawings. Some of his collectors drew attention to the speed with which Schiele could draw. And they pointed out another feature: the artist never used an eraser. If the model changed her position so that Schiele had to modify his drawing, he would draw a new line next to the old one instead of erasing what he had done. When he coloured his sketches or—as here—emphasised the outline additionally with opaque white, he would do so only after the model had left.

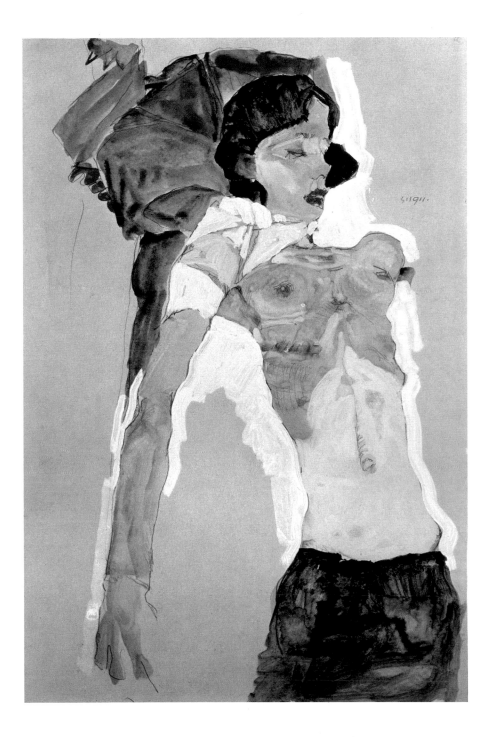

63

Hermits, 1912

Oil on canvas
181 × 181 cm
Leopold Museum, Vienna

In 1912 Schiele turned his attention to a new subject: he developed an allegorical level in his pictures—and frequently in very large formats. In *Hermits,* for example, two men in long dark habits clinging to each other in a barren, bleak landscape. The two figures are so closely intertwined that they seem to have become fused together. We viewers look slightly upwards towards them, which heightens the block-like impression still further. The younger of the two men has his eyes open, while the older man at his side seems to be dreaming with his eyes closed. Schiele has portrayed himself in the figure on the left, while many researchers see the man on the right as his mentor Gustav Klimt. Schiele himself, however, made no comment about this when he described the picture to the collector Carl Reininghaus. His interest did not lie in a realistic representation: "It is not a grey sky, but a grieving world in which the two bodies are moving; they have grown up in it alone, emerging organically from the ground; this entire world together with the figures aims to portray the 'frailty' of all beings [!]."

It was not only the melancholy, unwieldy subjects which impeded the sale of such works at the time; so, too, did their monumental size: the *Hermits,* for example, measures 180 by 180 centimetres. Schiele did not dispute the fact that such pictures were virtually unsalable; at the same time, they were also both time-consuming and hard work, and expensive with regard to the materials required. He told people that the allegories were of value to him alone. He saw himself as a prophet who had been called upon to paint—and who was also misunderstood by society. With this comment, the artist was reacting to the sentence he received in April 1912, after he had had to spend three days in prison because of drawings the authorities considered indecent. After his time in prison, he presented himself on a number of occasions as a hermit, a monk or a preacher. He initially remained faithful to these weighty themes.

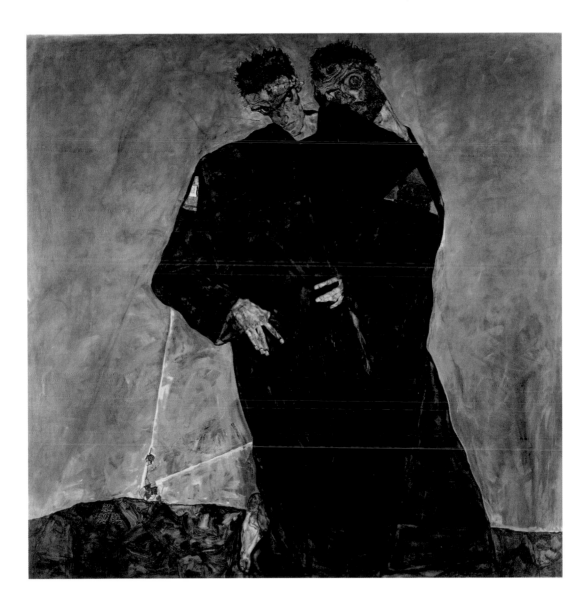

Cardinal and Nun (Caress), 1912

Oil on canvas
69.8 × 80.1 cm
Leopold Museum, Vienna

Small format—big effect. The painting shocked people: a cardinal and a nun are kneeling in front of each other, embracing. The nun has turned her horrified face towards the viewer; the cardinal seems to be paralysed as he approaches her. The hands and faces stand out clearly against her black and his bright-red robes, as do their naked legs and feet. The figures form a triangle against an almost-black background; the rigorous composition strengthens the dramatic effect.
Schiele himself called the picture *Embrace*. Here he seems to be referring to a famous work: five years previously, Schiele's great role model Gustav Klimt had painted *The Kiss*. In it, Klimt shows a couple embracing, fused in a kiss against an opulent gold background. Schiele's figures seem, by contrast, to be clutching at each other and look less rapt; here it seems to be a question of guilt rather than passion.
Schiele provoked his contemporaries with pictures on subjects like this. He repeatedly clashed with all conventions with his scandalous works—and not least through his own lifestyle. By now he was living in a common-law marriage with Wally Neuzil, whom he had met in 1911. She was initially his model before becoming his friend and companion. The couple is recognisable once again in the picture *Cardinal and Nun*.

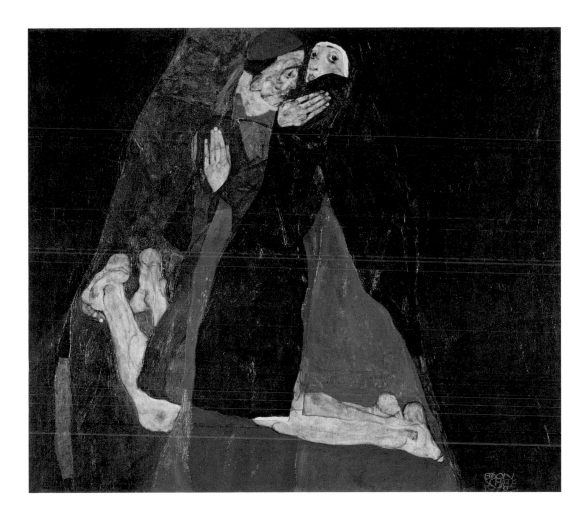

I Shall Gladly Hold Out for Art and for Those I Love!, 25 April 19

Pencil and watercolour on primed Japan paper
47.9 × 31.9 cm
Albertina, Vienna

From the summer of 1911 onward, Schiele lived and worked in Neulengbach, a little village in the Vienna Woods. But his sojourn finally ended in a catastrophe. Schiele was accused in April 1912 of seducing a minor and distributing immoral drawings. Although the more serious part of the charge proved to be without substance, the nude drawing from Schiele's studio which had offended public decency was burned before the court.

Schiele went beyond the constraints of all conventions with his erotic drawings. Even before he arrived in Neulengbach they had provided explosive material. Here, however, Schiele was even sentenced. The artist spent twenty-four days in prison, including the detention while he was awaiting trial. The experience was traumatic. Shortly after his release he wrote to his collector Arthur Roessler: "I am so miserable, I tell you; I am miserable to the depths of my being."

At least the guards allowed him to draw. Schiele sketched his prison cell on several sheets—the door and the chair, and the pallet with its grey sheets. Then he moved on to self-portraits, which he also painted in watercolour using dark, watery shades. The last sheet in the series shows the artist curled up under the thin grey blanket, his hands clenched, his head on one side. His face is contorted under his close-cropped hair.

The titles of these sheets often speak volumes, even though Schiele probably added them at a later date. On the self-portrait from 25 April he has written: "I shall gladly hold out for art and for those I love!" Schiele saw himself as a martyr, misunderstood by society: but for art and for love he was prepared to suffer.

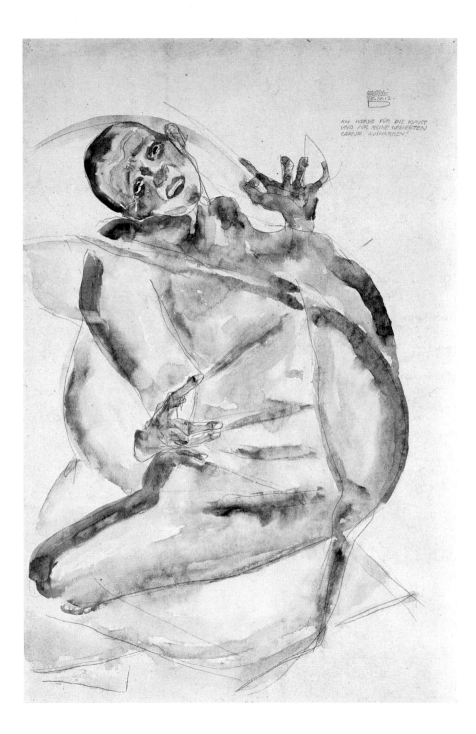

ICH WERDE FÜR DIE KUNST
UND FÜR MEINE GELIEBTEN
GERNE AUSHARREN!

Self-Portrait with Lampion Fruits, 1912

Oil and body colours on wood
32.2 × 39.8 cm
Leopold Museum, Vienna

Self-Portrait with Lampion Fruits is one of Schiele's best-known works. He painted the little oil picture in 1912. Schiele has turned to one side against a light background, but his gaze is fixed on the viewer. He looks self-assured and yet withdrawn. We can clearly recognise the individual brushstrokes, for example in the background or on his dark jacket. On the left, the lampion fruit (commonly known as Chinese lanterns) gleam bright red, suspended from thin twigs which still bear a few withering leaves. Schiele painted not only himself but also Wally Neuzil in this format (pages 72/73). He had met Wally, who had frequently served as model for Gustav Klimt, the year before; it was probably Klimt who introduced them to each other. Wally also modelled for Schiele initially; we can recognise her in many of his drawings from these years. Before long Egon and Wally became lovers and left Vienna to live in the country together. The fact that they never married turned their contemporaries against them, because a common-law marriage was contrary to the bourgeois ideas of the time. But their relationship held, and it even survived Schiele's prison sentence in the spring of 1912. For Schiele, the visits from his partner during these weeks in prison were the only bright spot. We can see in the two portraits Schiele painted later that year how close they were after this difficult time. The little wooden panels are the same size, and they show the same picture section: The figures are shown down to breast level, and their heads are cut off in each case by the top edge of the picture. Wally and Egon have turned to face each other. Since the portraits are composed as mirror images, they look like a double portrait with the two halves referring to each other. The pictures harmonise with each other not only in the composition, but also in the colouring: with light backgrounds, figures in dark clothing and autumnal shades of red and ochre.

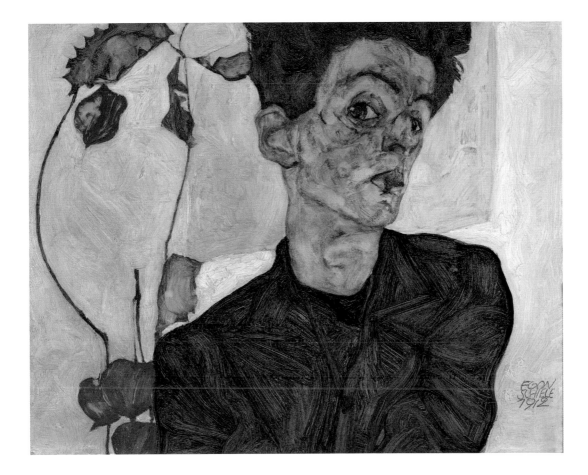

Portrait of Wally Neuzil, 1912

Oil on panel
32.7 × 39.8 cm
Leopold Museum, Vienna

The portrait of Wally Neuzil is regarded as the counterpart of Schiele's *Self-Portrait with Lampion Fruits*, which was produced at more or less the same time (pages 70/71). Wally's portrait has had a turbulent history, which was only reviewed in its entirety a few years ago. It shows how important it is to research the provenance of pictures in order to rectify possible injustice.

The little oil picture originally belonged to the Jewish art dealer Lea Bondi Jaray, who had to flee from Vienna in 1939 and whose property was expropriated by the National Socialists. After the war the portrait was erroneously returned not to her but to another collector. He in turn sold the picture to the Belvedere. The collector Rudolf Leopold acquired it from the latter.

It was only in 1997 that things started to happen. This was the year in which the New York Museum of Modern Art showed a major exhibition with works from the Leopold Collection, including the portrait of Wally Neuzil. At the end of the exhibition, it was confiscated by the United States authorities as stolen property, because the heirs of Lea Bondi Jaray in New York laid claim to the picture. This was the beginning of a legal battle which lasted for over ten years. It was unclear whether Leopold would be compelled to return the painting to its original owner. In the meantime, the case has been resolved and Wally's portrait has returned to Vienna to the Museum Leopold: in 2010 Rudolf Leopold's heirs purchased it from the heirs of the original owner for almost € 10 million. In this context, it was not only the history of Wally's portrait that was being reviewed: in 1998 Austria passed a law regarding the restitution of artworks, thereby enabling the return of confiscated art.

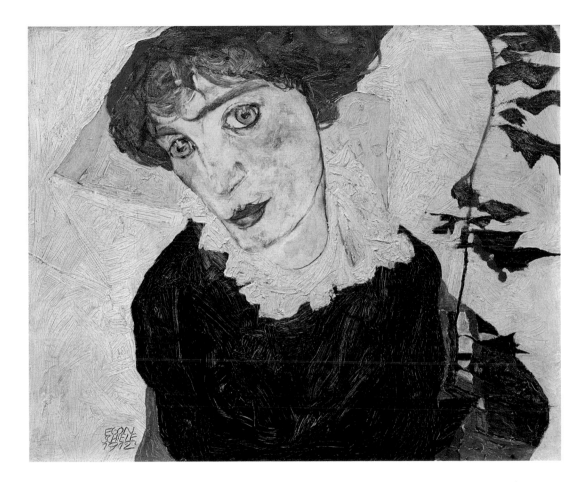

The Little Town I (Dead Town VI), 1912

Oil on canvas
80 × 80 cm
Kunsthaus, Zurich

The picture *The Little Town I* played an important role in Schiele's oeuvre: it was the first painting by the artist to be acquired by a museum. Schiele was just twenty-two years of age when the Director of the Museum Folkwang in Hagen, Germany, Karl Ernst Osthaus, purchased the square-format landscape. Osthaus had already acquired drawings by Schiele in 1910, followed one year later by nine watercolours. The two men corresponded frequently. In April 1912, Osthaus showed Schiele's works in the Museum Folkwang, together with works by other contemporary painters. And then, in the late summer, he purchased Schiele's *The Little Town I* for the museum—a major success for the artist.

The picture is one of many in which Schiele portrays Krumau. No other place inspired him as profoundly as the little town on the Vltava where his mother had been born. Schiele described the picture on the reverse as "Dead Town"—from 1910 he tended to give his pictures poetical titles. However, he painted an entire series of such "Dead Towns", which is why the numbers were added later. At the same time, however, Schiele also used the title "Little Town" for these landscapes.

So is it a little town or a dead one? Krumau lies dark beneath a dense black sky; only the occasional patch of colour stands out against the sea of houses. Huddled close together, the little houses with their dark windows look quiet and uninhabited. The strip of blue on the left-hand edge of the picture could refer to the Vltava, which flows through Krumau. Schiele, however, was less interested in recording the little town accurately than in portraying its symbolic content. In one of his Expressionist poems we find a line which suits this ghost town well: "Everything is living dead."

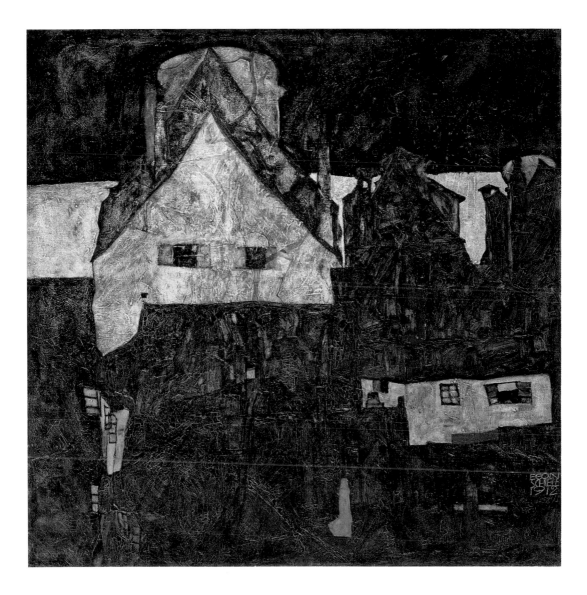

Autumn Tree in a Breeze
(also: Autumn Tree II, Winter Tree), 1912

Oil and pencil on canvas
80 × 80.5 cm
Leopold Museum, Vienna

Schiele's drawings focus primarily on the human figure. However, apart from his daring nude drawings he also favoured another subject which is all too easily forgotten: one-third of Schiele's oeuvre consists of landscapes. Like portraits, landscape pictures were also in demand at that time: his *Autumn Tree in a Breeze*, for example, went straight from the easel to the spring exhibition of the Hagenbund in Vienna. And in March 1912 it immediately found a buyer.

The crooked, leafless tree stands out against a distant range of hills, blowing in the stiff breeze. Clouds cover the greyish-white sky. The tree trunk is white; its gnarled branches and twigs contrast darkly with the background. The picture looks almost abstract, with the background subdivided into different forms by the spindly branches. As in his townscapes, here too Schiele focuses on the bleakness and emptiness of the foreground.

This almost abstract representation invites another interpretation: can we see the tree as a mirror of human existence? As a figure struggling alone against the cold winds? Schiele himself encourages these thoughts in 1913 when he describes his view of nature: "Now I mainly observe the physical movement of mountains, water, trees and flowers. Everywhere I am reminded of similar movements in the human body."

Portrait of Erich Lederer, 1912/13

Oil and gouache on canvas
140 × 55 cm
Kunstmuseum, Basel

When Egon Schiele's financial position worsened again in autumn 1912, Gustav Klimt came up with the idea that would save him. He introduced his fellow-artist to the Lederer family, who were great collectors of Secession art. The Austrian industrialist August Lederer knew and admired Klimt and collected his work. His family was one of the wealthiest in Vienna. After Klimt introduced the younger Schiele, their door stood wide open. Klimt took over the organisation and Schiele travelled: he spent Christmas and the New Year on the country estate of the Lederers in Hungary. August Lederer's son Erich, born in 1896, was also very interested in art. When his grandmother gave him a lottery prize amounting to 1,000 Kronen, the fifteen-year-old spontaneously decided to invest it in art: he commissioned Egon Schiele to paint his portrait.

Schiele made numerous sketches of Erich during his sojourn in Hungary for this commission. He experimented with various poses and views of his model. The oil picture finally shows Erich standing, life-size, turned slightly towards the viewer and with his left arm resting on his hip. The pale face stands out clearly against the earth tones which determine the clothing and the background.

The portrait marked the beginning of a long friendship. Erich Lederer subsequently took drawing lessons from Schiele, but above all he collected his works.

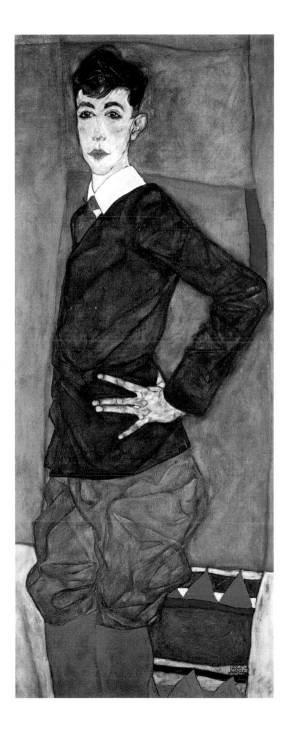

The Fighter, 1913

Pencil and body colour on paper
48.8 × 32.3 cm
Private collection

Schiele gave this picture its title from the start: he wrote "Fighter" ("Kämpfer") in
capital letters in the corner of the image at bottom right. It shows the gaunt, naked
figure of a young man. He is standing sideways to the viewer with his upper body
bent forward and his right shoulder turned towards the back. His left arm is bent and
the fingers are tensed, as if they are about to grasp something.
The man's entire body is composed of diagonal lines, thereby emphasising the
impression of movement. Only the thin face remains precisely vertical, although it
demonstrates as much tension as the rest of the body. The pencil drawing is still
visible, though Schiele has coloured the figure with dry brushstrokes in red, green,
blue and ochre.
What is the man fighting with such concentration? There is no indication on the
sheet: here, too, Schiele dispenses with a background of any sort which might tell
us more in order to concentrate entirely on the impressive figure. Researchers have
discovered that here Schiele probably depicted a sculpture of a swordsman from
Antiquity which he had drawn frequently as a student. But instead of showing the
sword or the actual fight, Schiele has distilled the expression of cumulative energy.
Schiele has signed the work in the left-hand corner of the sheet. Even as a student
the young artist added his signature or at least his initials to his works, both on paper
and on canvas. He also frequently noted the year he had produced the work next
to his initials. His signature later became more graphic: Schiele wrote his name in
capital letters and surrounded them with a rectangular frame, as can be seen here.
This framed signature became Schiele's trademark and he continued to use it for
many years to sign drawings, watercolours and paintings.

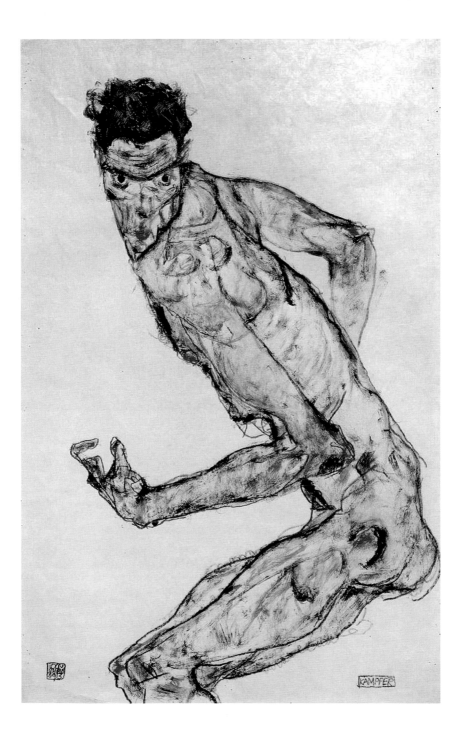

Double Portrait of Heinrich and Otto Benesch, 1913

Oil on canvas
121 × 131 cm
Neue Galerie, Linz

Heinrich Benesch visited an exhibition in the monastery at Klosterneuburg in the autumn of 1910. Various artists were displaying their works, but Benesch was full of enthusiasm for one particular picture: he liked a sunflower by Egon Schiele so much that he wanted to meet the artist personally. It was a fortunate encounter, and a momentous one, since Benesch would become one of the most important collectors of Schiele's drawings and watercolours.

By 1917 Heinrich Benesch owned an entire collection including seventy drawings by Schiele, although his budget was modest: he was a railway official. Benesch's enthusiasm knew no bounds, however, as he once write to the artist: "I should like to ask you for one thing more, dear Mr Schiele, please do not throw any of your sketches, whatever they may be, into the stove—not even the smallest, most unremarkable things. Please write the following equation on your stove in chalk: 'Stove = Benesch'."

In March 1913 Benesch commissioned the painter to produce a double portrait: Schiele was to paint him with his son Otto. Schiele shows the father with his back to the viewer and with his austere head turned to show his profile. He has stretched out his arm towards his son, his hand resting rigidly on the latter's shoulder. The very opposite of the dominant-looking father, Otto Benesch appears to be withdrawn; he has placed his hands one on top of the other and his narrow head is slightly inclined. The picture surface and even the faces have been subdivided into geometric shapes as in the works of Cubist artists, which Schiele probably knew. The range of colours is restricted to earthy shades of brown and grey, into which Schiele mixed white.

Otto Benesch was seventeen when Schiele painted his portrait. He continued his father's enthusiasm for Schiele's work when he became the Director of the Collection of Prints and Drawing at the Albertina in Vienna. He would later recall the portrait sessions with Schiele: "He used innumerable sheets during his preparations for a portrait. I was often able to observe him at work, especially when he created the life-sized double portrait of my father and myself [...] Schiele drew rapidly; his pencil slid, as if held by a ghostly hand, almost playfully across the white surface of the paper [...] He did not use an eraser; if the model shifted his pose he would place the new lines beside the old ones with the same unerring sureness."

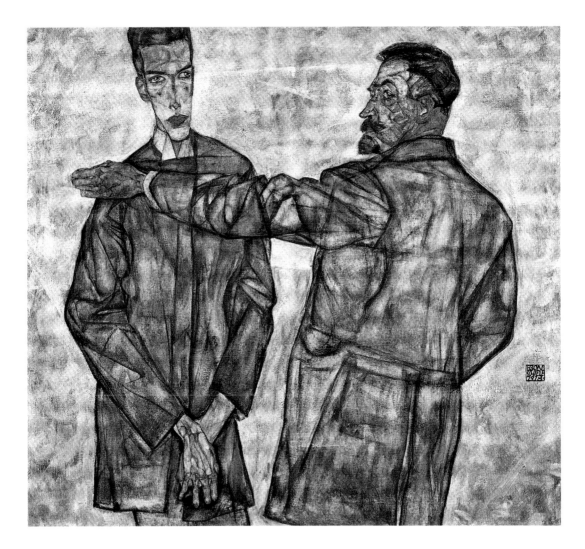

Woman in Black Stockings (Wally Neuzil), 1913

Gouache, watercolour and pencil on paper
32.2 × 48 cm
Private collection

Schiele's drawings, mostly executed with pencil and chalk, are not necessarily pre-liminary studies for pictures. On the contrary: most sheets are independent artworks. Accordingly, Schiele also signed his drawings exactly like his paintings. Schiele's collectors appreciated his drawings from the start. And the drawings, in turn, proved a valuable source of income for the artist. Some of them were published as reproductions in separate portfolios which were sold to collectors.

Schiele's erotic sketches were also desirable collector's objects even during his lifetime, and at times it was these that enabled him to keep his head above water financially. His model for many of these works, including the *Woman in Black Stockings*, was his partner Wally Neuzil. Here Schiele shows her from a low angle; she is leaning back with one leg crossed over the other. Her light petticoat has slid upwards across her thigh and the jagged hem has fallen to one side, so that the black stockings emphasise the naked flesh in between. Schiele displays as much as he conceals: the model has turned her head towards her raised shoulder and she has covered her upper body with her arm, whilst the splayed legs reveal her genitals. The undisguised sexuality which characterised Schiele's nude drawings was as radical as it was new. Nudity had been displayed in nude pictures for centuries, but it had remained primarily the preserve of goddesses or other allegorical persons. Schiele's nudes, by contrast, are daring; he shows real women, explicitly and in an unprettified manner, and without offering a narrative context. He thus put to the test the rigid sexual morality of his time. And he dared even more than that: his nude models do not gaze dreamily into the distance or even have their eyes closed. But they involve the viewer by gazing directly at him.

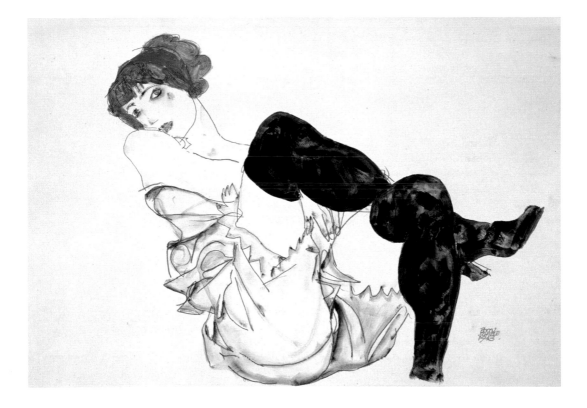

Houses with Colourful Laundry
(also: Two Blocks of Houses with Washing Line), 1914

Oil on canvas
100 × 120.7 cm
Leopold Museum, Vienna

The subject of this townscape is Krumau, the little town in Lower Austria in which Schiele spent two summers. Pictures like these were not produced on location, however. On the contrary: for many years the artist drew on impressions he had gathered during 1910 or 1911, painting his pictures after sketches made at the time. Schiele often combined several perspectives into a single picture, as he did in this work. We view the boats in the river at the bottom edge of the picture steeply from above, and the same applies to the washing lines and the colourful houses, but here we are gazing into a deeper picture space. The background is composed of horizontal stripes, against which the hills rise up, without however permitting the creation of depth within the picture. Schiele works to prevent a clear impression of space: a tactic which we also encounter in his figural representations. The artist has created a strict separation between figure and landscape; Schiele's towns are devoid of people. In *Houses with Colourful Laundry*, the muted colour palette heightens the impression of emptiness and silence; even the river is white, and the background merges into dark shades of grey and brown. Occasionally, a window sets a bright colour accent, as do the red posts and the colourful washing on the meandering line—but the blocks of houses nonetheless look deserted.

Schiele painted the picture in 1914, a grim year for him financially, at least until the autumn. Then a new collector and patron entered his life—Heinrich Böhler. Böhler took lessons with Schiele, paid him a monthly allowance and also purchased the *Two Blocks of Houses with Washing Line* for 500 Kronen.

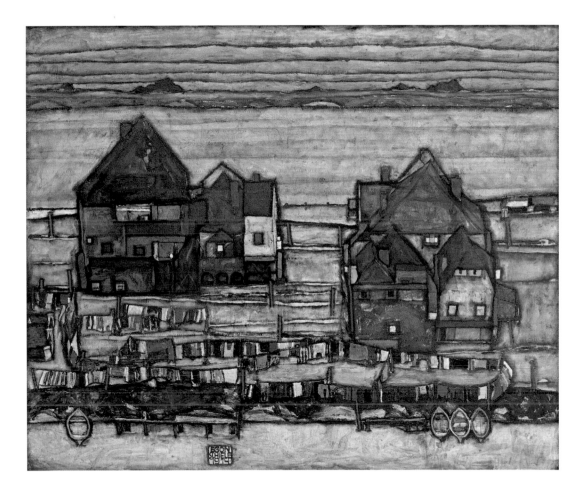

Female Lovers, 1915

Pencil and gouache
32.8 × 49.7 cm
Albertina, Vienna

Throughout his life Schiele drew naked or semi-naked female figures. Sometimes he showed them as couples, but mostly he drew them alone. His method of representation changed over time: in his early works Schiele often portrays a direct sexuality, women who gaze at the viewer and thus draw him or her into the picture. This changed after his traumatic experience in Neulengbach, where one of his drawings was burned in public. In the works that were created after this event, Schiele's eroticism is more concealed. He plays with forms and colours, tests poses in which the figures look still and contorted. Many of the female figures he drew in 1915 look almost doll-like.

With her button-like eyes the right-hand figure in the drawing from the Albertina in particular looks more like a jointed doll than a human being. The colours, too, seem far removed from nature as a slightly greenish tone has spread across the body. Here, once again, Schiele is breaking with taboos: in works like the *Female Lovers* he focuses on something which society of the time would have preferred to remain hidden.

Female nudes account for a large part of Schiele's oeuvre, but he also turned his attention to a wide range of other pictorial topics: he created portraits of fellow-artists and of his family, and he sketched landscapes, flowers and house façades. The speed with which Schiele drew repeatedly provoked comments. In this respect, the art critic Arthur Roessler's memories of his friend are important. He observed that Schiele had drawn unceasingly: "An untiring worker; as a draughtsman he became independent with remarkable speed; he was almost a virtuoso. His accurate pencil strokes flowed from his wrist. [...] He ignored no opportunity [for drawing]; and so we can understand that he always had a pencil in his hand, not only in his studio, but also in the open air, on the train, during journeys and in company during a conversation."

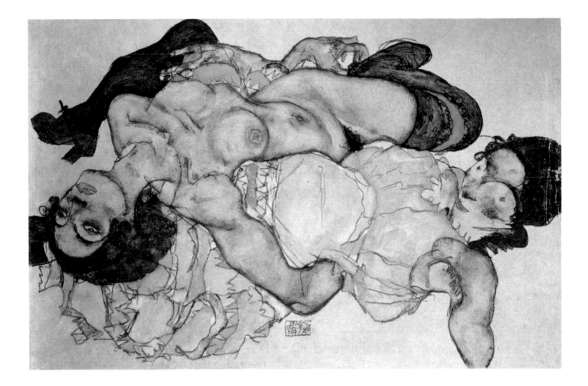

Death and the Maiden, 1915

Oil on canvas
150 × 180 cm
Belvedere, Vienna

Schiele was aware that his relationship with the artist's model Wally Neuzil did
not befit his social status. They were also not accepted as a couple during their
sojourns in the country, in Krumau and Neulengbach. Quite apart from Wally's
"dubious reputation" as a model, they lived together in a common-law marriage—
and that did not conform to the rigid moral code of the time. Schiele, however,
seems to have had no doubts about the relationship; Wally had been his companion
and one of his favourite models since 1911. That did not change until 1914, when
Schiele met Edith Harms. Before long the artist had decided to marry this daughter
from a good middle-class family. Edith made it clear that he would have to separate
from Wally before they could marry. And so, shortly before the wedding date,
Schiele ended his long-standing relationship with Wally Neuzil.

The large-format painting on canvas *Death and the Maiden* seems like the
conclusion to the relationship. Schiele painted it in 1915. The two figures are
cowering on a crumpled white sheet; Schiele himself, in a dark habit, is clinging
to the female figure with Wally's features. She has wrapped her arms around him,
but has inclined her head to one side and hence has turned away from him. The
landscape looks petrified and reflects the heavy, gloomy mood of farewell.
Schiele, however, did not give the work the title *Death and the Maiden* from
the beginning, but chose titles that go beyond this personal moment and hence
beyond the portrait-like element, such as *Entwined Couple* or *Man and Girl*. It
was under this title that he also showed the picture at the Secession Exhibition in
Munich in 1917.

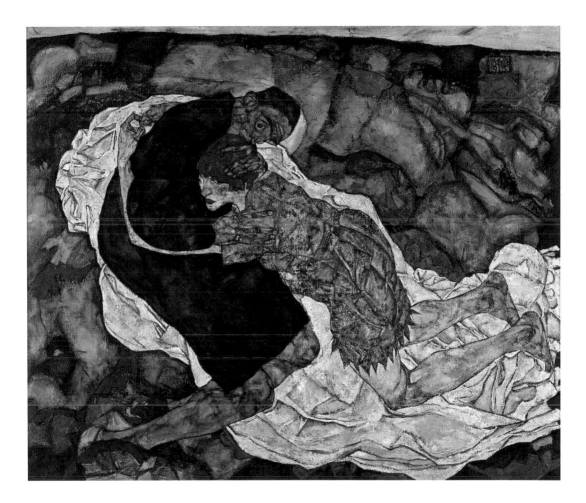

Seated Couple (Egon and Edith Schiele), 1915

Pencil and watercolour on paper
51.8 × 41 cm
Albertina, Vienna

1915 marked the beginning of a new chapter in Egon Schiele's life. His scandalous relationship with the artist's model Wally Neuzil was a thing of the past after Schiele ended their long-standing connection. That summer he married Edith Harms, a daughter from a good family whom he had met the previous year. Edith now became her husband's model—and banned him from drawing nude pictures of other women. The marriage was shaping up well, as a friend of the artist later remembered, "but Mrs Schiele was a sophisticated, medium-tall, very agile blonde, and was extremely jealous, which, however, bounced without effect off Schiele's good-natured composure".

In this self-portrait, however, the artist looks anything but composed. He drew Edith and himself on numerous occasions; the first double portraits were produced after their wedding in June 1915. Among the drawings was this watercolour, *Seated Couple*. They do not look like a happy, newly-wed couple at all. Although Edith has moved up close to her husband and is embracing him from behind, the two of them look strangely disconnected as they sit beside each other. Schiele is sitting and facing the viewer directly, but his twisted limbs look as if they do not belong to him. His right foot has been cut off by the bottom edge of the picture, and the large eyes in the emaciated head have a confused look. He is suspended in Edith's arms like a feeble doll, and his right leg looks dislocated as it lies entwined over hers. His light-coloured shirt has been pushed up and he is naked from the hips downwards. The angular contours of his body form a further contrast to his portrait of his wife. He has drawn Edith with softer, rounder forms, and she is also fully dressed and wearing a yellow-ochre dress, dark stockings and shoes. It is not clear what she is looking at; her face, too, remains numb.

As in earlier portraits, Schiele has continued to refrain from anchoring the figures in the picture surface. They are simply suspended in a space for which he has supplied no clues of any kind.

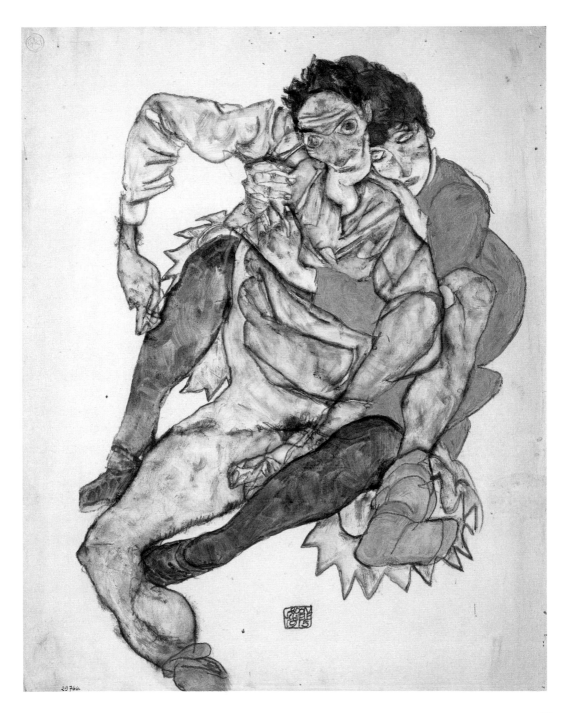

Portrait of Anton Peschka junior, 1916

Gouache and pencil
50 × 32 cm
The Cleveland Museum of Art, Cleveland

Schiele frequently drew and painted his favourite sister, Gerti, who was four years younger than he was. For many years she was his favourite model and he created numerous portraits and sketches of her. In her brother's circle of artists, Gerti became attracted to his friend, the painter Anton Peschka. Peschka was one of Schiele's colleagues; they had studied together at the Academy of Fine Arts in Vienna (pages 16, 40/41). When Gerti and Anton met, her older brother was anything but delighted. After all, Gerti was still a minor. Egon, of all people, who had lived in a common-law marriage for years with an artist's model, now stood on the side of bourgeois morals. Their mother was also strongly against the relationship, because the young couple flouted social conventions: the two of them even arranged to meet without an adult chaperon being present. At the beginning of the twentieth century it was still more or less unthinkable for lovers to meet unsupervised. The scandal seemed inevitable. In the summer of 1914, Gerti, then aged seventeen, became pregnant; her marriage to Peschka took place in November.
Schiele, however, evidently did not remain cross with his little sister for long. He gave her an oil painting, *Young Mother*, as a wedding present. One month after the wedding, Schiele's nephew, Anton Peschka junior, was born. From now on, little Anton became Schiele's model; the artist drew him frequently and even included the figure in some of his oil paintings. As so often, Schiele mostly dispensed with background details in these drawings, thereby creating bold perspectives. Here, for example, Anton junior seems to be balancing on a colourful piece of fabric or a blanket—or perhaps he is lying on the floor and Schiele has drawn him from above. As he had done with his earlier nude pictures, Schiele dictates the direction of viewing only by signing the sheet in a prominent place.

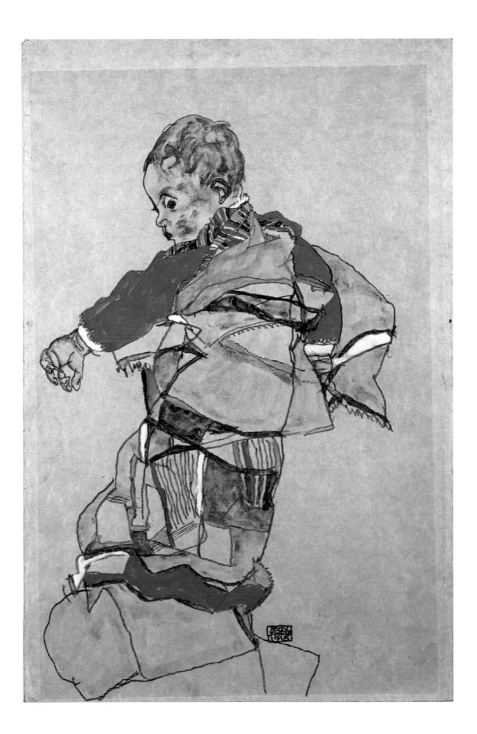

Lying Woman, 1917

Oil on canvas
95.5 × 171 cm
Leopold Museum, Vienna

Throughout Schiele's life, his study of erotic subjects mostly took the form of drawings. The drawing was the ideal medium for exploring his bold ideas about the body and sexuality: Schiele was able to work spontaneously and rapidly with a pencil or charcoal, and moreover the materials required were not expensive. Sometimes he even dispensed with his sketch block and recorded the figures on cheap packing paper. Whenever his models experimented with daring poses, Schiele was standing beside them with paper and pencil. What he did not like ended up in the stove. Oil pictures are less flexible: they must be elaborately prepared and are very time-consuming because the paints need a long time to dry. And last but not least, the materials that he needed for an oil painting were considerably more expensive than pencil and paper.

And so it is not surprising that Schiele rarely pursued his nude pictures of women and couples on canvas. The exceptions, however, prove the rule: and these include, for example, the picture *Cardinal and Nun* (pages 66/67), and also the large-format painting *Lying Woman*. This work is one of Schiele's few oil paintings with erotic content.

The model for the *Lying Woman* was Schiele's wife, Edith, although he made use of another female model for the head. The fact that the *Lying Woman* was composed from two different female figures could be due to a request from Edith. Schiele's friends describe her as jealous: after their marriage she asked her husband to draw her for his nude pictures and to no longer use other models. But perhaps Schiele did not want his wife to be recognisable in the nude drawing and so he decided to set another head onto her body. In any case, he liked to compose his subject from different sketches; we have seen his use of this working method, for example, in his landscape pictures. As he did there, so he also combines different views in the *Lying Woman* to form his picture, so that we see the figure partly in profile and partly from above.

Seated Woman with Raised Knee, 1917

Charcoal and gouache on paper
46 × 30.5 cm
National Gallery, Prague

In the roughly twelve years of his artistic career, Schiele's principal subject was the human figure. It was at the very centre of his work—in hundreds of drawings and pictures. Even from the beginning. In a letter to his Uncle Leopold as a young artist he declared: "I think that the greatest artists have always painted figures." He himself preferred to portray people—women and men, himself, small children and young people. He drew professional models and children from the neighbourhood, as well as his companion Wally. When Schiele ended the relationship in 1915 in order to marry Edith Harms, Wally also disappeared from his pictures.
After their marriage, Edith became the artist's main model, but Schiele also drew her sister Adele. It was said that his relationship to his sister-in-law was not quite as innocent as it should have been. Adele herself hinted as much on one occasion. It is also possible that she is the *Seated Woman with Raised Knee*.
This sheet from the National Gallery in Prague is one of Schiele's best-known drawings. It shows a slender young woman sitting on the floor. Her head is resting on her raised knee. Her hair has been pinned up, and the pensive gaze of her dark eyes is turned sideways. Her pose looks relaxed, and yet she also radiates a hint of provocation with her black stockings and her white petticoat, which has been pushed upwards. Schiele recorded the outline of the figure with charcoal, using strong colours to accentuate the green top and her wild, red-blond hair. For these Schiele used gouache, a material he often chose. It creates a surface which is more matt than that of watercolours, for example, and it also provides better coverage. Schiele lets the paper shine through in some places—for example on the black stocking of the bent leg. His brushstrokes can be clearly seen in the dry colours.

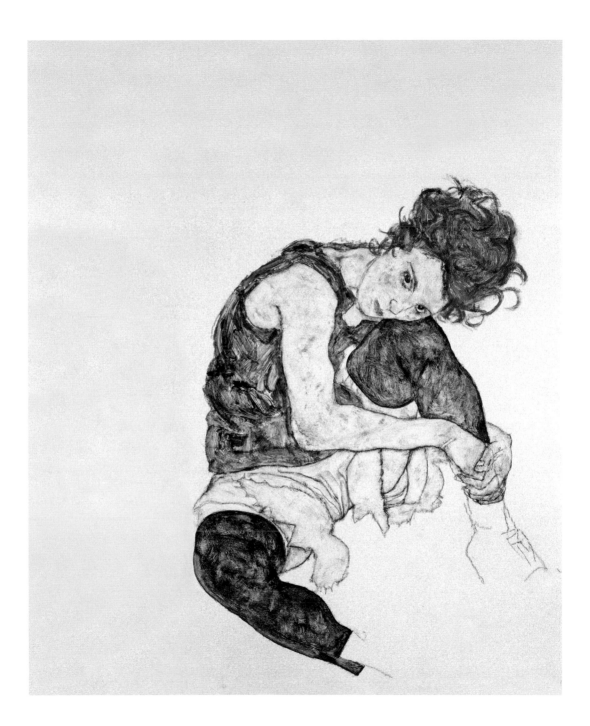

Four Trees, 1917

Oil on canvas
110.5 × 141 cm
Belvedere, Vienna

Schieles's representations of figures are so famous that we sometimes almost forget how many landscape pictures he also painted. He often recorded streets and houses in the little town of Krumau, but in many of his landscapes the protagonists are large sunflowers and wind-blown trees. In this large-format oil painting, which hangs in the Belvedere in Vienna, trees are also the central motif, but the mood has changed. Here there is no trace of the solitary, bare trees of winter which he painted during his early years (pages 76/77).

Instead, Schiele shows here an evening landscape in autumn in warm colours. The horizontal lines of the sky form a contrast with the four chestnut trees which rise vertically skywards. Standing in a row in front of gently rolling hills, they still have brownish-red foliage; one of the trees has already lost most of its leaves. In the distance, almost exactly in the middle of the picture, the sun is setting as a red ball of fire. The sky around it is bathed in the reddish stripes of the evening light, while further up Schiele has added darker shades of grey and blue. In some places we can clearly recognise the brushstrokes and splashes of colour on the canvas.

Schiele discovered this preference for symmetrical lines and patterns from another artist: Ferdinand Hodler. The Swiss painter became famous in Vienna following the exhibitions in the Secession. The young Egon Schiele must also have discovered him there and learned to appreciate his art. Characteristic of Hodler's style is this parallelism: a symmetrical picture structure, and the emphasis of horizontal lines and stripes of colour. Hodler recognised these patterns in nature and copied them in his pictures. The artists of Viennese Modernism were strongly influenced by his works—not only Schiele: Gustav Klimt was also impressed by Hodler's pictures. It was he who invited the Swiss artist to the Secession exhibition in 1904, thereby contributing in no small measure to Hodler's fame.

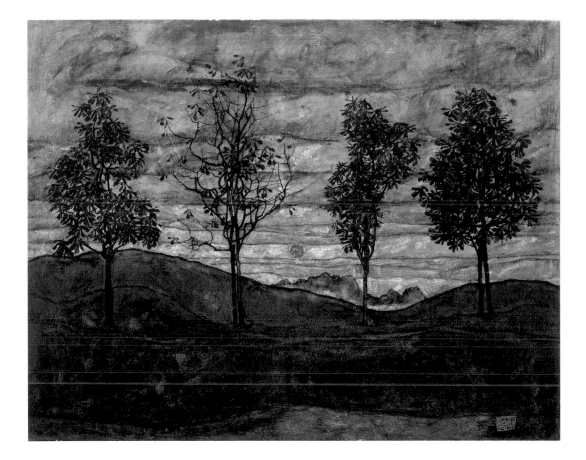

Portrait of Edith Schiele, 1917/18

Oil on canvas
139.8 × 109.8 cm
Belvedere, Vienna

"I believe that today at least one picture could hang in the St.-G. [Staatsgalerie]", wrote Egon Schiele to his friend and patron Arthur Roessler in 1916. Schiele's wish was fulfilled just one year later: Franz Martin Haberditzl, the new Director of the Staatsgalerie, purchased several of the artist's drawings. That was a major success, but even better things were to follow in 1918: Haberditzl also purchased the large-format portrait Schiele had painted of his wife Edith. And so one of Schiele's oil paintings found its way into an Austrian museum for the first time.

However, the picture initially looked somewhat different: Edith's long skirt was covered with a colourful checked pattern, as an old photo shows. Schiele painted over the skirt in a lighter shade and made the graphical pattern disappear. He also changed some other details: the white collar of the blouse has become scalloped in the second version, and the bright orange top has been changed to a modest shade of blue. Moreover, the tips of Edith's shoes, which are not shown in the first version, can now be seen peeping out from under the hem of her skirt.

The earlier version of the portrait hung in the Secession Exhibition of 1918. It was probably Haberditzl who advised Schiele to make the changes to Edith's costume. We assume that he found her skirt too decorative. In any case, for the past century Edith Schiele has been enthroned in somewhat more subdued colours in the Belvedere, as the Austrian Staatsgalerie is known today.

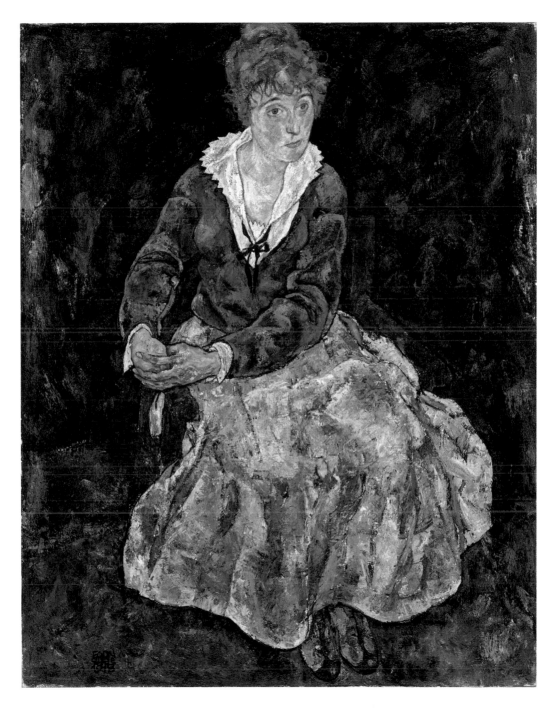

Exhibition Poster for the 49th Vienna Secession, 1918

Colour lithograph on paper
68.5 × 53 cm
Vienna

The 49th Exhibition of the Vienna Secession focused above all on Egon Schiele: the prominent centre room in the building was reserved for him, and he showed almost fifty of his works there—oil paintings, watercolours and drawings. The exhibition was a great success, both artistically and financially. Schiele sold five of his paintings and several drawings while the exhibition was still in progress. He was delighted at the large number of people interested in his work: "I think people are incredibly interested in my new art. [...] On the opening day you really couldn't move at noon,—so many visitors."
Schiele was not only the principal artist in the exhibition; he had also been in charge of the organisation of the show during the previous months. He had even designed the exhibition poster on the basis of his painting *The Round Table*. In the poster he harked back in a highly symbolic way to depictions of the Last Supper. He shows a group of artists, immersed in books and sitting at a large, rectangular table.
We cannot easily recognise the people he has portrayed, but it was intended to represent Schiele's artist colleagues who supported the modern approach to art, including Paris von Gütersloh, Anton Faistauer and Otto Wagner. Schiele himself is sitting at the top end of the table; the empty chair at this end of the table, on the other hand, recalls Gustav Klimt, who had died a short while previously.
The exhibition poster was produced using the technique of lithography. Here the subject is drawn onto lithographic stones, and these are then used to print the image on paper, each stone printing a different colour. Usually about 300 to 400 prints of lithographs like this were made, but during this final year of the war it may have been fewer. The yellowish paper is thin—after all, the posters were intended for advertising purposes and were not supposed to be preserved indefinitely.

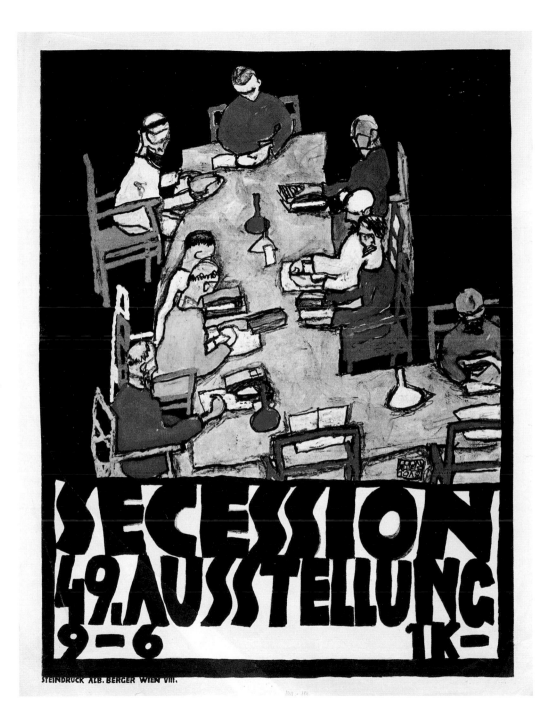

The Family (Crouching Couple), 1918

Oil on canvas
152.5 × 162.5 cm
Belvedere, Vienna

This large-format nude picture from the year of Schiele's death poses a number of riddles. Three people are crouching behind each other before a gloomy background. At the top, the man is staring wide-eyed out of the picture, while in front of him a woman with her head lowered is gazing vacantly into nothingness. A small child is lying on the brightly coloured blanket at her feet. The figures do not look as if they are connected in any way, as each one is gazing in a different direction. Although it is tempting to see the figures as portraits, the artist himself called the picture *Crouching Couple*. It was not until after Schiele's death that it was given the title *The Family*.

The figure of the man can be clearly recognised as a self-portrait of the artist. The position of his hand seems to point to this: Schiele had often portrayed himself with this same gesture, with the forefinger and middle finger splayed out. However, the woman crouching in front of him bears little resemblance to Schiele's wife Edith. The little child is a late alteration; initially a bunch of flowers could be seen in its place. Once more, the model for the boy who was subsequently added to the picture was Schiele's nephew, Anton Peschka junior. Is it possible that Schiele added him to the picture after learning that his wife was pregnant?

The painting method in this picture demonstrates the development that Schiele's style underwent at this time, towards more realistic or even idealised representations. However, the foreground looks as if it is not quite finished, and the painting has not been signed. It is possible that Schiele did not finish it.

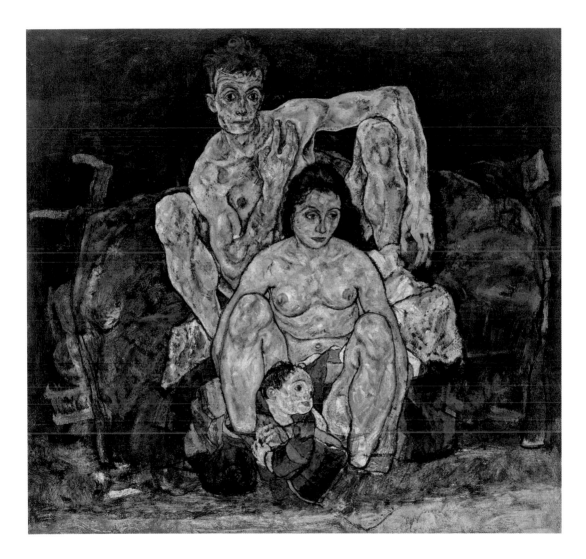

Portrait of Paris von Gütersloh, 1918

Oil on canvas
140.3 × 109.9 cm
The Minneapolis Institute of Art, Minneapolis

Albert Paris von Gütersloh was also an artist—and a man of many talents. He painted and he acted, designed stage sets and directed plays, restored churches and designing stained-glass windows. And Gütersloh also wrote: in 1909 he was working on his first novel, *Die tanzende Törin* (The Dancing Fool). He became one of the forerunners of literary Expressionism with the work. During this time, he joined the New Art Group, of which Egon Schiele was one of the co-founders. Gütersloh presented his works in the group's first joint exhibition. While creating art himself, he also wrote about it at the same time: he explored modern art in essays, wrote articles on the activities of the New Art Group, and published magazines. In 1911 he wrote his first essay on Schiele's artistic achievements. Gütersloh saw painting and writing as being of equal value.
Egon Schiele was also convinced that writing and painting belonged together. At the beginning of his artistic career, he wrote poetry and later published some of his poems in a magazine. "I believe that every artist must be a poet", he noted in April 1918. During this year, he also painted a portrait of his long-standing friend Albert Paris von Gütersloh. The illustrious-sounding name was, incidentally, a pseudonym: Gütersloh was born Albert Konrad Kiehtreiber. At the beginning of his stage career he called himself Albert Matthäus. By the time Schiele painted him he had found his final artist's name.
Schiele admired the artist, who was three years his senior, for his versatility. This large oil painting shows Gütersloh in a moment of creative inspiration: he is sitting erect and gazing in concentrated fashion, his hands raised as if to grasp at his idea. The portrait is signed, but Schiele left it unfinished. Nonetheless, this work is an outstanding portrait of Austrian Expressionism.

"Art cannot be modern; art has always existed."
Egon Schiele

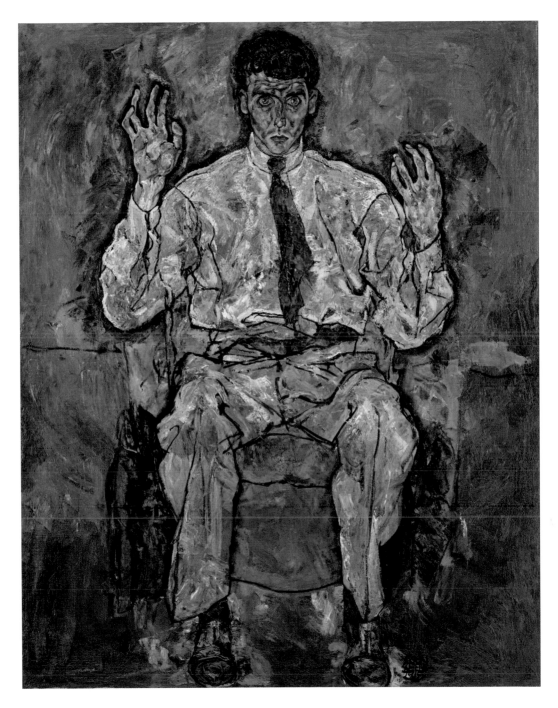

FURTHER READING

Bauer, Christian, *Egon Schiele: The Beginning*, Munich 2013

Bauer, Christian, *Egon Schiele: Almost a Lifetime*, Munich 2015

Bisanz-Prakken, Marian/ Clegg, Elizabeth/ Kallir, Jane, Klimt / Schiele: *Drawings from the Albertina Museum*, Vienna 2018

Comini, Alessandra, *Egon Schiele's Portraits*, Berkeley 1974

Gaillemin, Jean-Louis, *Egon Schiele: The Egoist*, London 2008

Husslein-Arco, Agnes/ Kallir, Jane, Egon Schiele: *Self-Portraits and Portraits*, London and New York 2011

Kallir, Jane, *Egon Schiele's Woman*, Munich 2012

Kallir, Jane, *Schiele, Egon: Life and Work*, New York 2003

Kallir, Jane/ Vartanian, Ivan *Egon Schiele: Drawings and Watercolours*, London 2003

Leopold, Rudolf, *Egon Schiele: Landscapes*, Munich 2004

Leopold, Elisabeth, *Egon Schiele: Poems and Letters 1910–1912*, Munich 2008

Natter, Tobias G., *Egon Schiele: The Complete Paintings 1909–1918*, Cologne 2017

Schröder, Klaus Albrecht, *Egon Schiele: Eros and Passion*, Munich 1995

Whitford, Frank, *Egon Schiele*, London 1981

Online: Kallir Research Institute, *Egon Schiele: The Complete Works*: http://egonschieleonline.org/overview

PHOTO CREDITS